Paint Charming
Cottages
&Villages

Kerry Trout

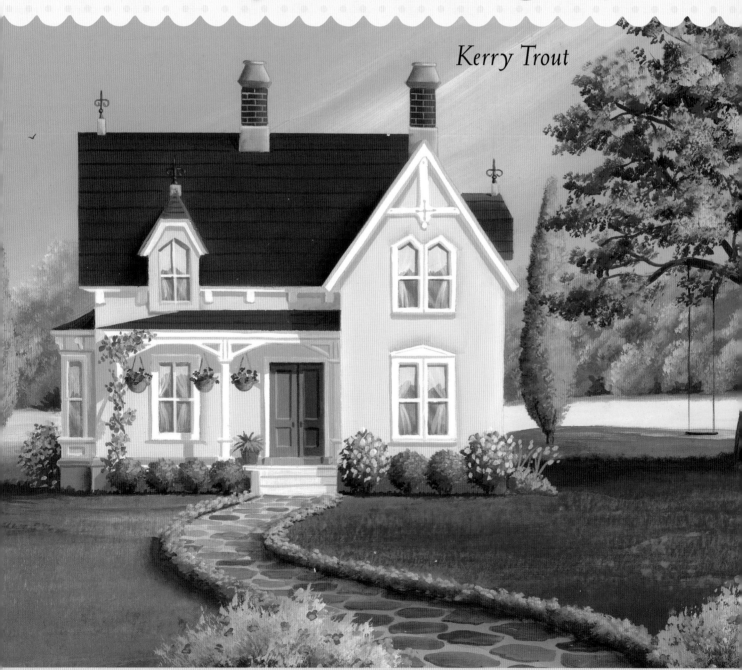

NORTH LIGHT BOOKS
CINCINNATI, OHIO
www.mycraftivity.com

Paint Charming Cottages & Villages. Copyright © 2008 by Kerry Trout. Printed in Singapore. All rights reserved. The patterns and drawings in this book are for personal use of the reader. By permission of the author and publisher, they may be either hand traced or photocopied to make single copies, but under no circumstances may they be resold or republished. It is permissible for the purchaser to paint the designs contained herein and sell them at fairs, bazaars and craft shows. No other part of this book may be reproduced in any form or by any electronic or mechanical means including information storage and retrieval systems without permission in writing from the publisher, except by a reviewer who may quote brief passages in a review. Published by North Light Books, an imprint of F+W Publications, Inc., 4700 East Galbraith Road, Cincinnati, Ohio, 45236. (800) 289-0963. First Edition.

fw Other fine North Light books are available from your local
F+W PUBLICATIONS, INC. bookstore, art supply store or direct from the publisher.

12 11 10 09 08 5 4 3 2 1

DISTRIBUTED IN CANADA BY FRASER DIRECT
100 Armstrong Avenue
Georgetown, ON, Canada L7G 5S4
Tel: (905) 877-4411

DISTRIBUTED IN THE U.K. AND EUROPE BY DAVID & CHARLES
Brunel House, Newton Abbot, Devon, TQ12 4PU, England
Tel: (+44) 1626 323200, Fax: (+44) 1626 323319
Email: postmaster@davidandcharles.co.uk

DISTRIBUTED IN AUSTRALIA BY CAPRICORN LINK
P.O. Box 704, S. Windsor NSW, 2756 Australia
Tel: (02) 4577-3555

Library of Congress Cataloging in Publication Data
Trout, Kerry,
 Paint charming cottages & villages / Kerry Trout. -- 1st ed.
 p. cm.
 Includes index.
 ISBN-13: 978-1-60061-133-9 (pbk. : alk. paper)
 1. Cottages in art. 2. Cities and towns in art. 3. Painting--Technique. I. Title. II. Title: Paint charming cottages and villages.
 ND1460.D94T76 2008
 751.4'26--dc22
 2008019842

Edited by Jacqueline Musser
Designed by Clare Finney and Brian Roeth
Production coordinated by Matt Wagner
Photographed by Christine Polomsky

Deckard Studios, Danville, IN

About the Author

Kerry is a self-taught artist who has been painting since she was a child. She is the author of four North Light Books: *Handpainting Your Furniture, From Flea Market to Fabulous, Decorative Mini Murals You Can Paint* and *Handpainted Gifts for All Occasions*. From her Indiana studio, she paints wall murals on canvas, creates one-of-a-kind furniture and teaches painting classes. Kerry considers the highlight of her career to be having her painted ornament chosen for the 2003 White House Christmas Tree, and getting a personal invitation to go there and be honored by First Lady Laura Bush.

Kerry developed Liquid Shadow©, the first product of its kind for decorative painting. Liquid Shadow© is a water-based medium that enables painters to easily paint cast shadows and to deepen shading. It was awarded "New Product of the Year" in 2003 by the Society of Decorative Painters, and is fast becoming a must-have for artists. For more information about Liquid Shadow©, visit www.kerrytrout.net, Kerry's official Web site and home of Liquid Shadow©.

Metric Conversion Chart

To convert	to	multiply by
Inches	Centimeters	2.54
Centimeters	Inches	0.4
Feet	Centimeters	30.5
Centimeters	Feet	0.03
Yards	Meters	0.9
Meters	Yards	1.1

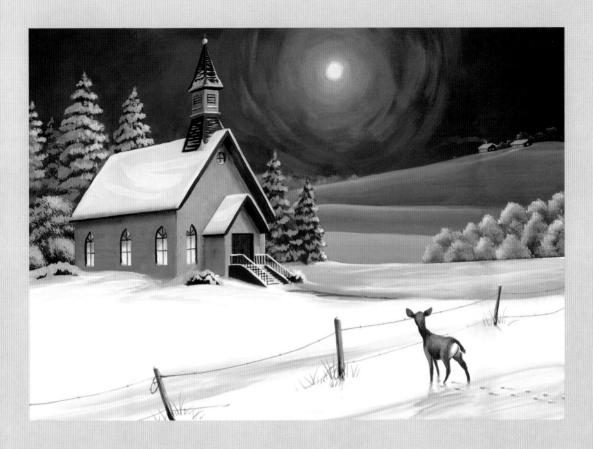

Acknowledgments

I'd like to acknowledge a few people who helped make this book possible. Sharon Spencer, my assistant and good friend, who took over other projects so that I could meet my deadlines; Rosemary Reynolds for happily supplying me with DecoArt paints; Kate Ingram of Scharff for graciously sending me the brushes needed for my photo shoot; and my husband Tom, for his patience, love and support, which are always so appreciated when I'm working on a book!

Special thanks goes to North Light's Kathy Kipp, who asked me, once again, to create a book for them. I have admired her professionalism and cherished her friendship over the years. To Jackie Musser, for fast becoming my favorite editor. She made things so much easier for me; and to Christine Polomsky, who has been the photographer for all of my books. Her expertise amazes me, and her enthusiasm and effervescence somehow always turn a stressful week-long photo shoot into a fun and memorable experience. My sincere gratitude to all of you.

Contents

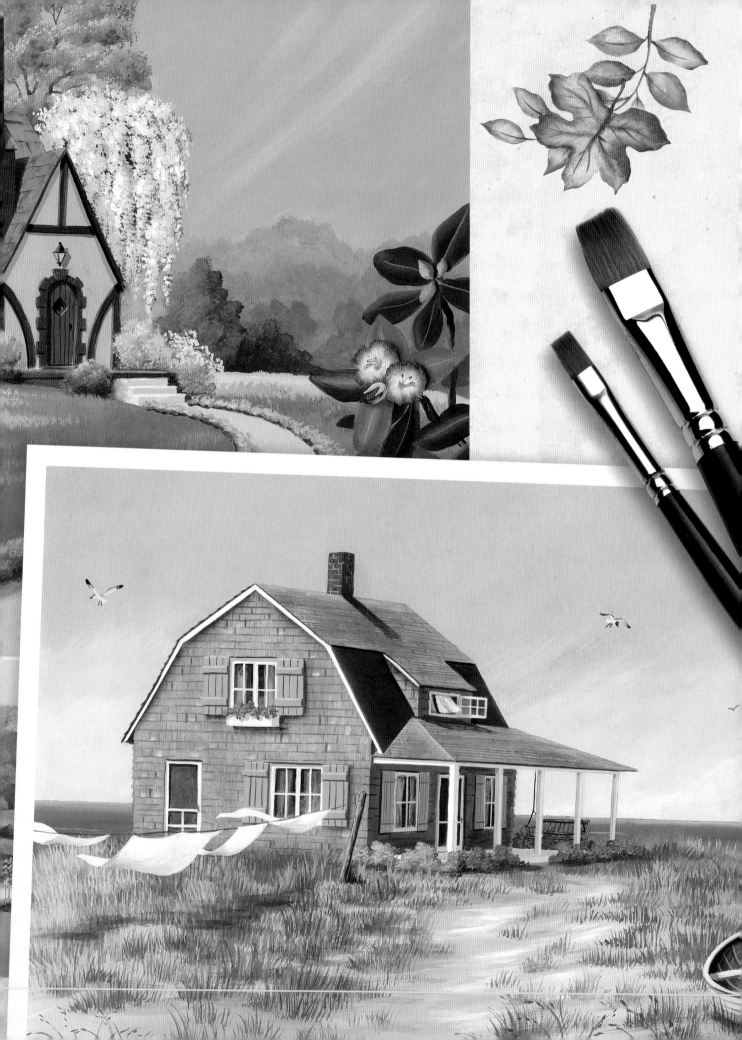

Introduction

I have always been fascinated with the architecture of old homes, and I love to include quaint cottages and antique storefronts in my paintings. A little house or cottage in a landscape becomes the focal point—what the viewer's eye is drawn to. There are so many types of homes that enhance our paintings—from rustic, early European bungalows to fancy Victorian cottages. So when the editors of North Light asked me to do a book on the subject, I jumped at the chance. For the following projects, I have chosen the styles of homes I like to paint the most, and I hope you have as much fun painting them as I have.

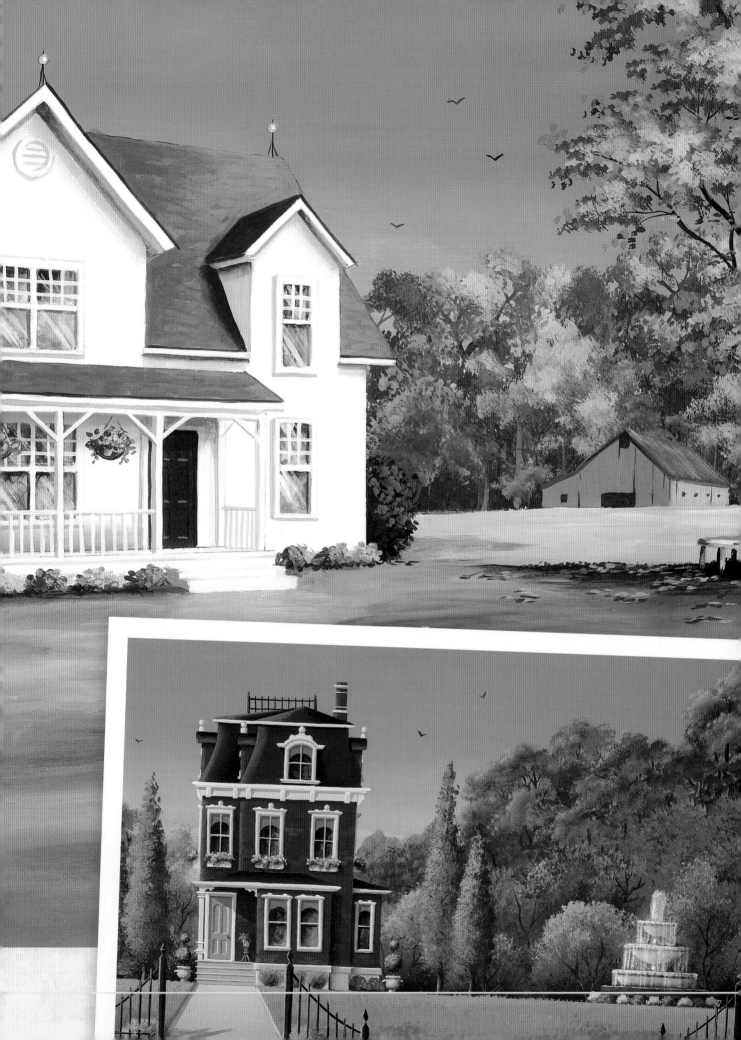

Materials

Brushes

Familiarize yourself with the brushes required. You probably will have most of them in your paint box, but I use a few specialty brushes that make very cool strokes and just make painting so much easier.

If you are just starting out, I always recommend buying the best brushes you can afford. Cheaply made artist brushes won't keep their shape and will lose bristles. When you have to pick hairs out of your work, you know you have a bad brush. (One exception is the mop brush. It has baby-fine bristles and even the best mop brushes lose hairs occasionally.) So get good brushes, and with proper care, they can last years. I use Scharff brushes. They are extremely well made, hold up nicely, and create beautiful strokes.

Acrylic paint is very hard on artist brushes, so use a good brush cleaner at the end of the day, and lay your brushes down on paper towel to dry. Don't allow them to lay on a soaked paper towel, though. The brush handle (if it is wood) will absorb the moisture and eventually split the paint on the handle and loosen the glue in the ferrule. Only after the brushes have dried completely should you stand them back up on end in your brush holder. Standing up a wet brush will allow the water to sink down into the ferrule and wreak the havoc described above.

When painting, be sure to keep a bowl of clean water at your work area. This is especially important when floating colors and working with pastel washes. Dirty water will give you incorrect colors.

Don't let your brushes sit in the water bowl. It makes the bristles misshapen and softens any glue in the ferrule. An art teacher informed our class that if she saw any brushes standing in water, she would confiscate them. And she did so. It didn't take us long to remember that rule!

Additional Tools

Other tools needed in these projects are as follows:

- **T-Square:** A straightedge with a right-angled T on the end. I have two on my work table, a 12-inch (30cm) and a 24-inch (60cm). I used the smaller one for the projects in this book because of its handy size. But I also use the large one against the edge of my table. It's as square and true as it was seventy years ago when my dad used it in college drafting!

- **Metal Ruler:** I use this when I need to cut a straight edge with my razor knife. The blade won't cut the ruler as it often does to a wooden ruler.

- **Craft Knife:** A comfortable handle can be a plus, and always keep a supply of fresh blades.

- **Masking Film and Tape:** I don't enjoy the time it takes to tape off edges in my paintings, but I love the clean straight lines it gives me! Plus it actually saves time in painting, so I tape a lot, as you will find out. I use household "magic" tape, 1-inch (25mm) painters' tape, ¼-inch (6mm) quilters' tape and masking film, which is a clear film with a sticky side that comes on a roll or in a tablet. Please don't be tempted to use regular masking tape (tan in color). Its adhesive is too strong and may rip your paper when you take it off. The painters' tape I use is Scotch 3M #2080 Painters' Tape for Delicate Surfaces. It's blue and has a smooth, untextured finish that will prevent paint from seeping under the tape.

- **Chalk Pencil or Soapstone Pencil:** I find a soapstone pencil lasts much longer than a chalk pencil

1. T-square; 2. Masking film; 3. Metal ruler; 4. Chalk pencil; 5. Soapstone pencil; 6. Liner brush; 7. Scroller brush; 8. Mop brush; 9. Flat shader brush; 10. Round brushes; 11. Wisp brush; 12. Flat brushes.

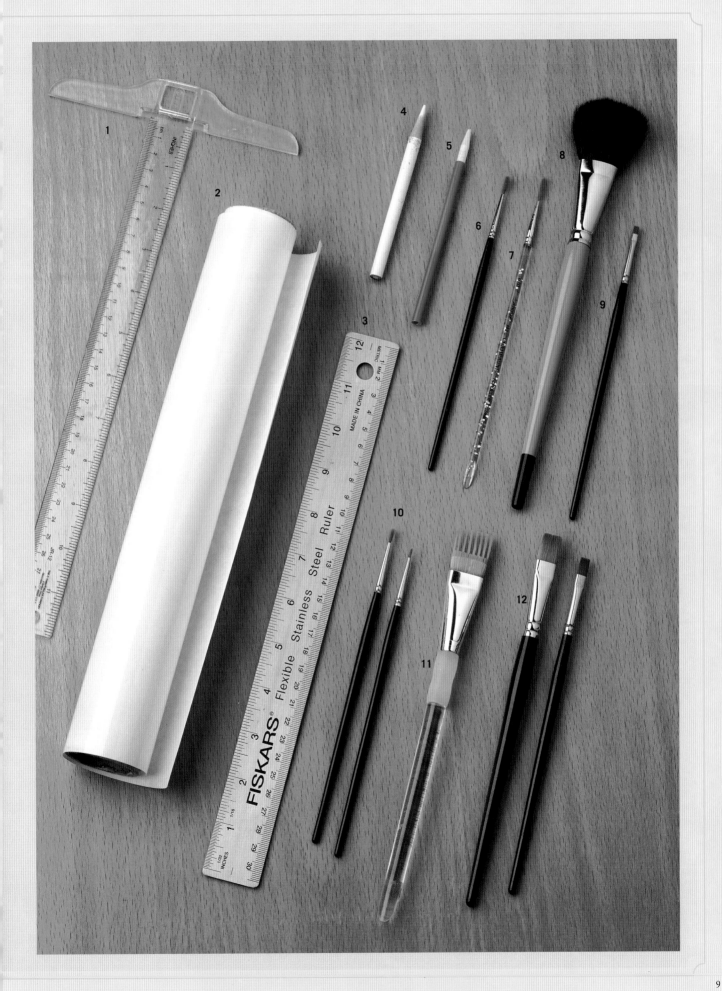

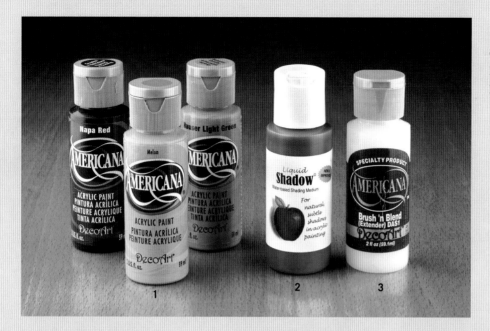

1. DecoArt Americana acrylic paints; 2. Liquid Shadow©; 3. Blending gel.

because it is harder and more durable. You can sharpen them to a fine point in a pencil sharpener. Look for them in the quilting section of your local craft store.

- ART GUM ERASER: This is gentler and more thorough than a regular pencil eraser.

- TRANSFER PAPER: Also called graphite paper, both black and white are needed for the projects in this book. (Do not use transfer paper used in sewing!)

- TRACING PAPER: A translucent paper used to trace images and patterns.

- LIQUID SHADOW©: A water-based medium that allows you to make natural-looking shadows. It is available online at www.kerrytrout.net or at www.artistsclub.com.

- BLENDING GEL: A clear gel solution used to keep paint wet for easier blending.

Surfaces

Choose your surface wisely. If you intend to paint on canvas, gesso the surface and sand it well so you have a perfectly smooth surface on which to paint. If you are using paper, get good-quality, untextured watercolor paper of a heavy weight, bristol board, or coldpress art board. If you are like me and often paint on other surfaces, such as wood or tin, prep the surface accordingly.

I always seal any work done in acrylics. After my painting is dry and any pattern lines erased, I brush off the surface with a large, soft-bristled brush (that I use for this purpose only) then either spray the surface with a commercial artist's grade polyurethane or brush on two coats of water-based satin polyurethane. While acrylics are essentially a flat paint, applying a sealer makes the colors come alive, and protects your painting as well.

Paints

All of the projects in this book are painted with Americana acrylic paints by DecoArt.

Before You Begin

Setting up your canvas or paper is important when you are going to begin any of these projects. I tape down my paper first on a drawing board, using a T-square to make sure the paper is square on the board. I keep it secured to the board until I finish. I use the T-square when I lay the pattern down, aligning vertical lines with the T-square to ensure a correct plumb. Later, when you use your T-square to chalk in roof tiles or window panes, your lines will always be level and plumb with the rest of the painting. This is essential!

I have written the directions to the projects as thoroughly as space allows, but please read the instructions through completely before beginning any of the projects.

Using Perspective

Painting portraits of houses can be challenging and a bit scary, but if you follow a few basic rules, you can successfully create the cottages and villages just as I have in this book.

As far as the rules, I'm talking about the importance of perspective. Perspective is the representation of parallel lines as converging in order to give the illusion of depth and distance. Without following the rules of perspective, a painting of a building can look awkward and just plain wrong. You don't have to worry too much about the rules, though, because these projects are already designed for you. In case you want to try your hand at painting your own cottage or candy store, I'd like to show you the fundamentals of perspective.

Lets start with a landscape. After all, it is the basis of every project in this book. In a typical landscape you see the sky and the earth (in some form whether its forests, mountains or ocean). Where the sky and the earth meet is called the horizon. From the viewer's vantage point, the horizon is always at eye level. If you have buildings, animals or people in your landscape, they are likely to stand in front of the horizon in some way.

On a horizon, there are vanishing points. If you have a three-fourths view of a building, the horizontal lines (gutter, window tops and bottoms) on one side will all eventually meet at a vanishing point on the left. The same lines on the other wall of the building will meet at another vanishing point to the right. This is called two-point perspective. Let me show you an example.

In the *Correct* diagram, you will see a house drawn correctly, following the rules of two-point perspective. You see the horizon, which is the eye level. This is how you would view the house if you were standing in front of it at this distance. Notice the two vanishing points on either side. See how the horizontal lines on the house would meet at the vanishing points? Now look at the same house in the *Incorrect* diagram. It was quickly drawn without paying attention to perspective. It is certainly out of whack, isn't it? Not until I draw in the perspective lines can you see how much.

For a thorough and complete guide to the laws of perspective, I recommend the book *Perspective Made Easy* by Ernest R. Norling.

I followed the rules of perspective in most of the projects in this book. But since I have artistic license, as do all painters and designers, I can do anything I want in my work. And that's what I did in the *Italiante Cottage* (page 30), the *Queen Anne Cottage* (page 90) and both villages scenes. I used a straight-on view, and although it is not realistically correct, it is easier to paint and still pleasing to the eye.

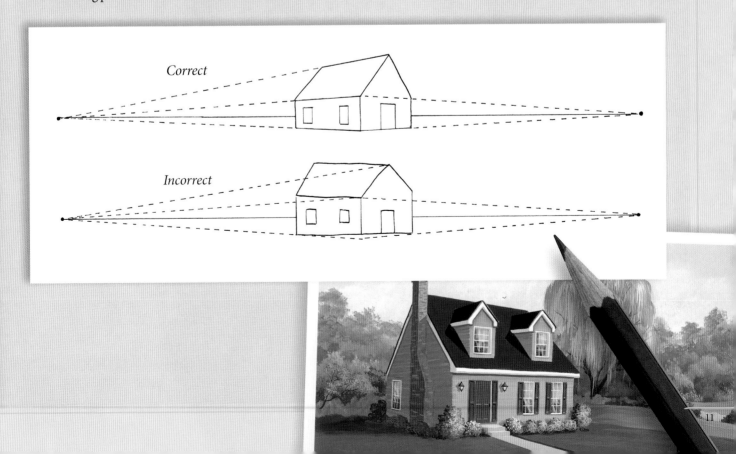

Correct

Incorrect

Techniques

Most techniques used in this book are explained and demonstrated, and if you are an experienced decorative painter, you are already familiar with them. If you are a beginner, the best advice I can give you before you start a project is to study the techniques section and practice, practice, practice!

Applying and Removing Masking Film

Masking film will help you preserve the individual areas of your painting. It also gives you crisp, straight lines.

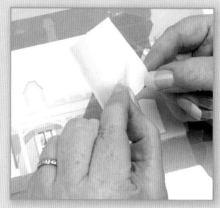

1 Remove the backing from the film and place it over the area to be masked.

2 Use a sharp craft knife to carefully cut around the detail sections that need to be preserved individually (it is important to use fresh blades).

3 To remove the excess, lift a corner of the film with the tip of a craft knife.

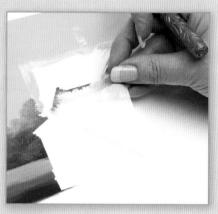

4 Pull the corner up and then continue to pull the masking film away from the surface of the painting.

Blending Liquid Shadow©

Liquid Shadow© is a water-based medium that allows you to make natural-looking shadows.

1 Load a flat shader brush with Liquid Shadow©. Apply the brush to the paper. The Liquid Shadow© will go on thin and transparent.

2 Use a dry mop brush to blend the color out.

Floating

Floating is a great technique for adding shadows and showing contour.

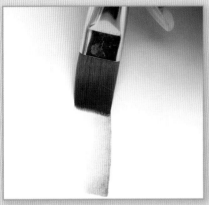

1 Wet your brush; tap the excess water on a paper towel. Dip one corner into the paint.

2 Sweep the brush back and forth in the loading zone of your palette to work the paint into the bristles. Don't turn your brush over—you need to keep the paint on one side of the brush.

3 When your color "floats" across the bristles like this, it's time to make your stroke.

Creating Dip Dots

Dip dots are the easy way to make perfectly round little circles. They can be used in so many ways. They are used to create the bittersweet in the *Country Farmhouse* painting (page 20), and the Christmas lights in *Village Christmas* (page 120).

Because they involve more paint, dip dots require longer drying time before you can add highlight color.

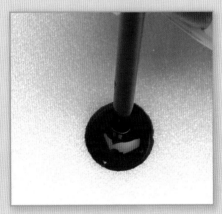

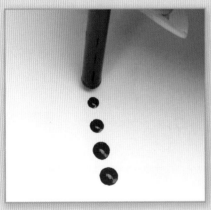

1 Dip the nonbristle end of a brush into paint.

2 Dot the paint onto the surface to create small circles. One dip is good for about four dots. The dots become smaller with each mark as the paint is unloaded from the end of the brush.

Using a Comb Brush

A comb brush, also called a rake, is an essential brush to have in your collection, and once you use it, you'll wonder how you ever got along without it! Combs have extending hairs that, once loaded, create very thin lines. I make my grasses with this brush, and it is also perfect for painting animal hair. Combs come in either a flat or filbert shape, which is a flat brush with a rounded end. Load a comb as you do a liner, which is with very watery paint.

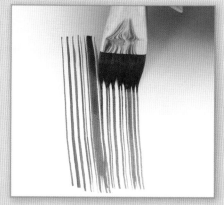

1 Create a very watery mix of color and load it on your brush. I always load the comb brush to the ferrule for maximum paint retention.

Creating Grass in Drifts

Comb brushes are ideal for painting grass. In this book I used a comb brush to paint the beach grass in *Seaside Getaway* (page 78) and the dried grass coming out of the snow in *Chapel in Winter* (page 102). A cardboard mask makes painting an uneven drift of grass easier than you would think.

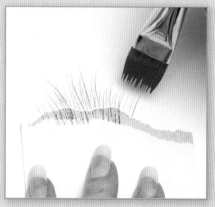

1 Tear a piece of paper or thin cardboard so that it is uneven. Load a comb brush with thin paint. Start your stroke on the cardboard and pull up. Always end your strokes by lifting the brush off the surface. This creates a natural, tapered point. Arch your stroke in just the slightest way so that your grass doesn't look stiff.

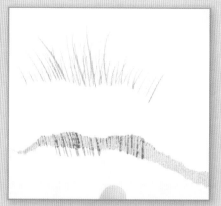

2 When you pull the cardboard away, you'll see the grass starts at different heights as if coming out of a drift of snow or sand.

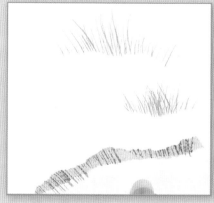

3 Put another layer of strokes over the first to achieve a realistic patch of grass.

Using a Wisp Brush

A wisp brush works on the same principle as a comb, but the bristles are fuller and hold more paint. By adding pressure to your strokes, you can get wider blades of grass. I use this brush in foregrounds where my grasses don't have to be so fine. It is also used for straight striping. I used a wisp brush to create the siding on the homes in the *Little Cape Cod* (page 68) and *Seaside Getaway* (page 78) demonstrations.

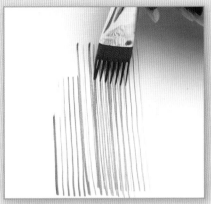

1 Make a very inky mix of color by thinning the paint down with lots of water. Load the brush thoroughly so that paint works all the way through it.

2 Pull the brush across the paper. You'll see it creates a series of straight lines.

Loading a Scroller

A scroller, also called a liner, is essential for any artist. You should have them in several sizes. Longer-bristled scrollers are called script liners. When loaded properly, they enable you to make quite long, continuous lines with consistent paint coverage. I once demonstrated to my students how long a line one well-loaded scroller would make, and I wrote the alphabet from *A* to *Z*! They are amazing brushes.

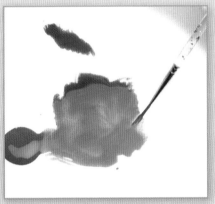

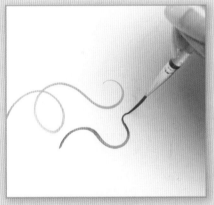

1 Add enough water to the paint to create an inky consistency. Load the brush all the way to the ferrule. Pull the brush straight out of the paint. You'll be tempted to twist the brush in the paint but avoid doing that.

2 The scroller makes long, thin lines and is good for placing delicate shading on the sides of windows and trims.

Using a Rubber Band Stippler

Stippling is a great technique for adding foliage and texture to a painting. I like to stipple with a homemade stippler made from rubber bands. The flowering pink tree in the *English Country Cottage* (page 44) painting is created with a rubber band stippler.

Feel free to experiment with the rubber band stippler and use it wherever blooms are dabbed on, like the flowers in Steps 17–22 in the *English Country Cottage* and in other projects in the book. Have fun with it!

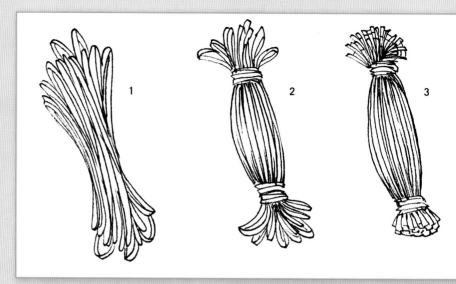

1 Gather fifty small rubber bands (approximately 2 inches [5cm] in diameter).

2 Wrap each end with two rubber bands, as tightly as you can, leaving a ½ inch (13mm) on either end.

3 With small scissors, cut open every loop. Trim one end closely (⅜-inch [10mm]) to the wrapping bands, and trim evenly. Cut the other end so the ends are about a ½ inch (13mm) long. They will be more ragged than the other end. Now each end will produce a different style of stipple.

4 Load the rubber band stippler with paint. Pounce the stippler up and down on your paper. Wash the stippler in warm soapy water to clean.

This is what a finished rubber band stippler looks like.

Creating a Bush Using Pouncing

All of the bushes in this book are painted using this technique. Vary the sizes and types of your brushes to create different effects. When my flat shaders are pretty much worn out, I don't throw them away—they get demoted to scruffies. Scruffies are perfect for making all sorts of foliage and bushes. Susan Scheewe makes a foliage brush that creates great effects, and I am using one of those brushes in this example. Whether you buy a foliage brush, or use your own scruffy, here are the basic steps to painting easy bushes.

1 Make a puddle of Black Green and a puddle of Avocado close together on your palette. Dip your brush into both of the paints at the same time. Push your brush into your palette to work the paint into the bristles.

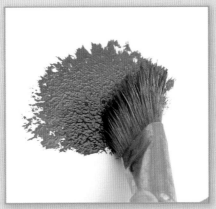

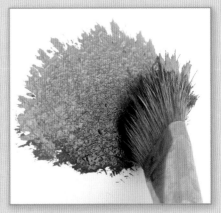

2 Hold the brush vertical and pounce up and down as shown in the first photo. Then pivot your wrist so you fan out the top of the bush as shown in the second photo.

3 Add Hauser Light Green to just the tip of the brush and work it into the bristles in the loading zone. Then pounce this color on the top part of the bush only. This adds highlight.

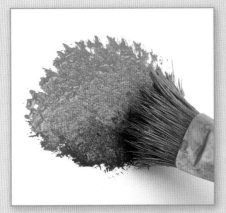

4 Clean the brush and load it with the color of your choice (here I used Boysenberry Pink). Pounce the color on top of the Hauser Light Green. The bush does not have to be dry before adding the flower color.

5 Add Titanium White to your flower color to create a lighter shade. Pounce this shade on top of the color very sparingly as a highlight.

6 Notice I have concentrated the white more on the left side of the bush. This is because the sun is coming from that side.

Creating Easy Foreground Leaves
Use this technique for painting the leaves in the *Country Farmhouse* painting on page 20.

1 Double load a no. 6 flat with two complementary colors.

2 This leaf is made with an S-stroke. You can draw an S on paper to practice this. Place the brush at the bottom of the S.

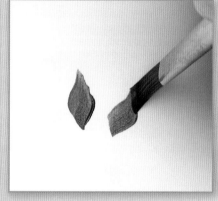

3 Pull upward slightly, then press down on the brush, going off to the upper right.

4 Pull upward again just as you did in the beginning of Step 3. Lift up on the brush to end the stroke.

5 This is what your leaves should look like when you finish the stroke.

Painting Grass

Use the comb brush to paint the grass.

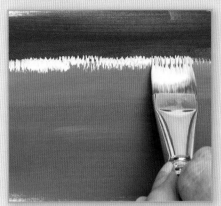 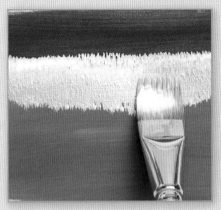 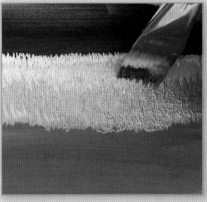

1 Apply a basecoat color for the grass. Load the comb brush with your lighter color. Here, I'm using Lemonade, but the color will vary depending on the painting. Tap the color along the edge of the grass. You are striving for a fuzzy irregular line for distant grass.

2 Gradate down to a darker green (here, Hauser Light Green). As you move closer to the foreground, use longer strokes.

3 Start stroking upward to blend the colors, making sure your strokes are short and don't brush out any previously made strokes above them.

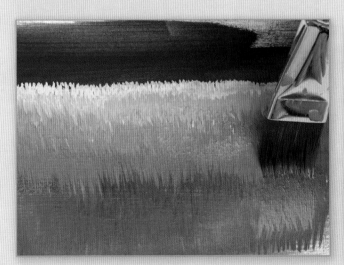 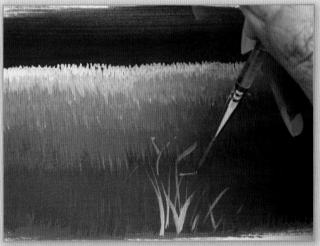

4 As you get even closer to the foreground, switch to a darker green. You're creating a slow transition of color. As you move down the painting, your paint needs to be thinner so you can sweep the color upward and blend the colors. Your strokes also need to be longer.

5 For foreground detail grass, switch to a scroller and use lighter shades of green. Stroke in grass blades and tall weeds. This is not necessary in every foreground, but adds interest in the lower corners of a painting and around fence posts, bridges and water.

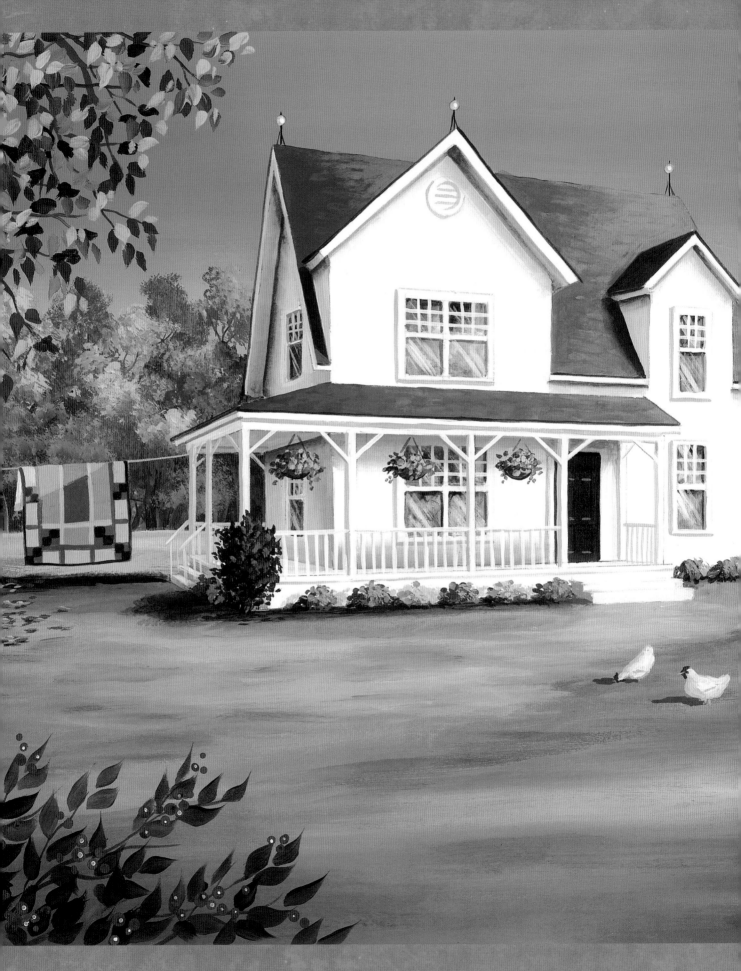

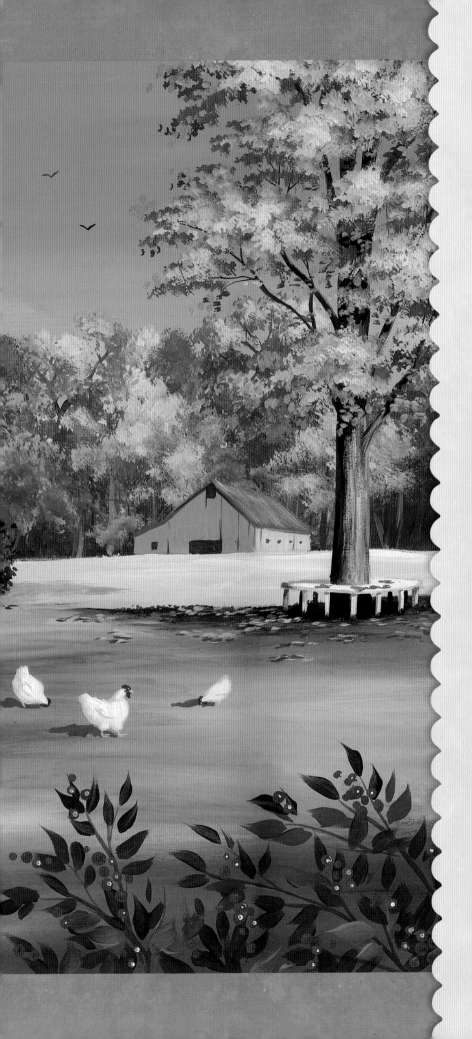

Country Farmhouse

I love farmhouses with wraparound porches! This humble scene is a classic representation of where many of us live here in Indiana, including me. One of the prettiest scenes I get to enjoy is a crisp fall day when the trees are in their full crimson and gold splendor. I can't think of any other time when the sky is a more vivid blue than in October. I thought this pristine white farmhouse would be perfect for such a colorful backdrop.

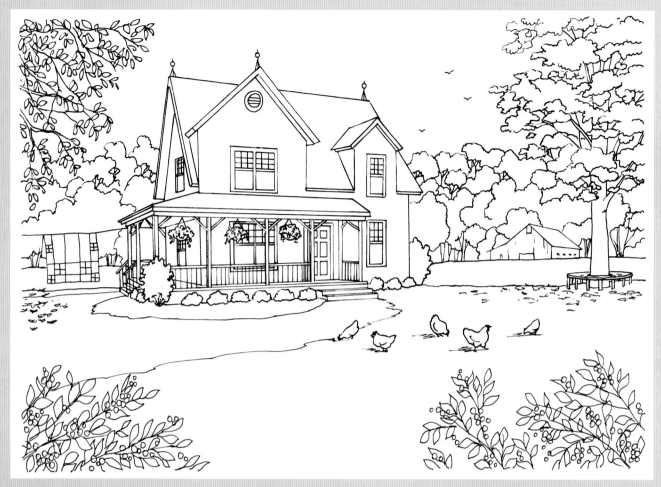

This pattern may be hand traced or photocopied for personal use only. Enlarge at 192% on a photocopier to bring it up to full size.

Before You Paint

For this demonstration, I basecoated the house after I placed masking film on it and cut out the white areas. But a good time-saving trick is to basecoat the entire canvas with Warm White. Then when it comes time to paint the house, it's already basecoated.

Trace and transfer the pattern. Apply masking film to the entire house. Cut around major elements. Remove the masking film from any area that will remain white.

Background Foliage

Start by taping off to protect the horizon line, which, in this case, is the top edge of the field where the barn sits. Use a scruffy brush and pounce in different blends of browns, greens and Georgia Clay. The goal here is to remove the sky color from the horizon by about 1 inch (25mm). This will give the appearance of dense woods.

Next, stroke in tree branches above the dense woods with varying shades of Graphite and Dark Chocolate. Use the no. 6/0 scroller. Only paint high branches that are against the sky. Anything closer to the ground will be hidden by other trees.

Then, use a small scruffy brush to pounce in clumps of oranges, browns and greens. There is no ratio here for colors, just use different blends of Cocoa, Georgia Clay, Marigold and Avocado. Highlight a few of the trees by lightening the tree color with a touch of Snow (Titanium) White.

Make smaller, closer trees beneath those with pounced mixes of Avocado, Marigold and Cocoa. Keep them off the ground, however, and stroke in tree trunks with a no. 1 round loaded with Graphite. Add some Snow (Titanium) White to the Graphite to make some of the trunks a lighter gray.

Sky, Distant Field and Foreground

Paint the sky with Calypso Blue. The distant field is painted with blends of Camel and Snow (Titanium) White. Paint the driveway with blends of Driftwood and Slate Grey. The grass is blends of Avocado, Light Avocado, Evergreen and Hauser Light Green.

Materials

DecoArt Americana Acrylics

Antique Maroon

Avocado

Black Green

Calypso Blue

Camel

Celery Green

Cocoa

Country Red

Driftwood

Ebony (Lamp) Black

Evergreen

Georgia Clay

Graphite

Grey Sky

Hauser Dark Green

Hauser Light Green

Honey Brown

Light Avocado

Marigold

Napa Red

Neutral Grey

Payne's Grey

Primary Yellow

Slate Grey

Soft Lilac

Terra Cotta

Whites

Antique White
Snow (Titanium) White
Warm White

Brushes

Nos. 2, 4, 6, 10 and 14 flats
Nos. 3/0, 0, 1 and 2 rounds
No. 6/0 scroller
Flat scruffy
Small round scruffy

Additional Materials

Masking film
Craft knife
T-square
Soapstone pencil or chalk
Stencil
Pencil

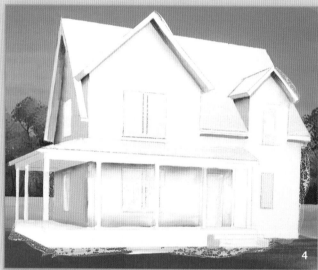

1 Paint the entire left side of the house, including the roof trim and the ceiling of the porch, with a mix of Grey Sky + Soft Lilac (1:1). Use a no. 6 flat to paint the porch on the left side. Feel free to switch to a smaller brush if you feel more comfortable. Nothing's worse than using a large brush in too tight an area. If you use a round brush, it's very important to blend your brush strokes out because these brushes leave brush marks behind.

Remove the masking film from the left side of the front-facing gable and dormer and paint these sides with the same shade color. Paint this color under the right side of the eaves on the gable and dormer as well. Also paint the left side of the front steps.

2 Float the shading color on the house under the eaves on the gable and dormer using a no. 14 flat. The float on the right side needs to be wider because there is more shade on that side of the house. Float this color beneath the roof of the porch and above the floor of the porch on the front of the house. You can either tape off the porch posts or float around them to preserve the whiteness.

3 Pencil back in any lost lines using a T-square. Use a no. 10 flat to float Graphite against the left-side eaves. Also float Graphite on the house beneath the porch roof on both sides of the porch. Float Graphite under the eaves on the left side of the gable and dormer.

4 Make a very thin wash of Graphite and use a no. 2 round to run the wash under all of the eaves to create some heavier shading. Make the shading heaviest in the peaks of the eaves. Make sure the wash is very thin, because you want the first shading color (Grey Sky + Soft Lilac) to show through. Also run just a line of watery Graphite under the left gable eaves and the left dormer eaves and the front gutter of the house.

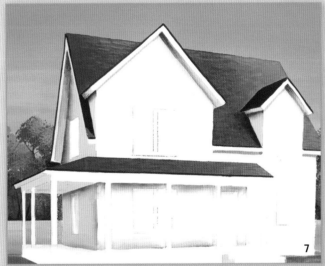

5 Remove the masking film from the roof. Tape off the areas around the roof to protect them from paint. Basecoat the left side of the roof with Avocado. Basecoat the right side with Hauser Light Green. In the middle, transition between these two colors with very loose blends. You'll fix this transition in the next step, so don't worry if it looks a little off.

6 Make varying value mixtures of Avocado and Hauser Light Green. Load these mixtures into a no. 6 flat and dab the color from the chisel edge of the brush onto the roof to create the illusion of shingles. Keep perspective in mind as you dab on the "shingles."

7 Remove the masking from around the house and touch up any problem areas where the masking wasn't straight or where any bleed occurred. Paint the left side of the dormer roof and the small strip of roof to the left of the

gable with a mix of Black Green + Avocado (2:1) using a no. 2 round. Run this color down all roof lines with the no. 6/0 scroller.

Load Avocado + Hauser Light Green (1:1) on a no. 2 round and place a small amount of this light color on the very corner of the small strip of roof next to the gable.

Shade the roof on the left side of the dormer with a no. 6 flat and the Black Green + Avocado (2:1) mixture. Soften the edges a bit with water.

8 Remove the masking film from the windows. Paint the windows with a light blue wash of Warm White + a touch of Payne's Grey. Add straight Payne's Grey to the tops of the windows. Mix Avocado + Hauser Light Green and dab just a little bit of this color on the bottom of the window. In the bottom of the windows on the front porch, wet the lower part of the window with clear water and drop in a touch of Georgia Clay to show a reflection of autumn foliage.

9

10

11

9 With the no. 2 round add diagonal strokes to the windows with a very thin wash of Warm White. This gives the illusion of reflecting glass. Use a soapstone pencil or chalk and a T-square to mark in the window panes. With a no. 2 round and Warm White paint in the cross trim on the windows. Because you are covering a darker color, you will need to apply a few coats of the Warm White.

Load a wash of Payne's Grey on the no. 6/0 scroller and paint a shadow on the glass that runs beneath the middle and top trim and down the right side of the trim. This helps add depth to the window. Use the no. 6/0 scroller to paint the trim on the smaller window panes.

10 Load very thin Grey Sky + Soft Lilac (1:1) on a no. 6/0 scroller and run a fairly thick shadow around the left side and bottom of the window trim (where the trim casts a shadow on the house). Run thinner lines of shadow on the right side and top of the window trim.

Use a stencil and pencil to mark a circle near the peak of the gable. Run the Grey Sky + Soft Lilac shadow around the left side of the circle only with the no. 2 round. Come in about ⅛-inch (3mm) and create the same type of shadow on the inside of the circle. Add three louver lines to the inner circle, keeping in mind that the louvers must be at the same angle as the shingles on the roof. On the right side of the circle add a small crescent highlight of Warm White. Let the paint dry and remove your pencil lines. The negative space creates an illusion of depth.

11 Basecoat the door with Country Red and a no. 4 flat. With the no. 10 flat, float Napa Red on the top of the door. Along the top and the right of the door, run a thin line of Antique Maroon. Use a soapstone pencil or chalk to mark in the panels. Paint the tops and right sides of the panels with Antique Maroon. Highlight only the bottoms of the panels with Country Red + Warm White (1:1). You can also run a thin line of Grey Sky + Soft Lilac (1:1) around the door for trim. Erase your chalk line when you finish.

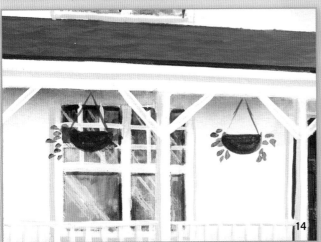

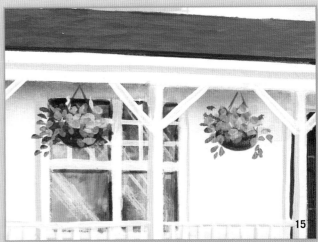

12 Use a pencil to very faintly sketch in the porch post braces. Paint the braces Warm White with the no. 2 round. You may need to use several coats of Warm White on the braces to get proper coverage. This area is too small to mask, so you'll need to keep applying paint until you are satisfied with the coverage. Run Grey Sky + Soft Lilac (1:1) down the left side of all of the posts. Also run this shadow under the front trim on the porch.

13 Use a soapstone pencil or chalk and a T-square to place the porch railing following the line of the bottom of the porch. Paint the porch railings with a no. 6/0 scroller. For contrast, paint the railing with Grey Sky + Soft Lilac (1:1) wherever the railing is against the white of the house. Paint the railing Warm White wherever it is against the shaded part of the house. Due to perspective, the vertical railing posts to the right of the door are closer together than the posts to the left of the door. Again for contrast, place the Grey Sky + Soft Lilac shadow to the left of the vertical railing posts when they are against the white of the house.

14 Basecoat the hanging flower baskets with Hauser Dark Green. Simply paint a semicircle to create the basket. Extend very faint lines of Graphite from the porch trim down to the baskets. Use the no. 6/0 scroller for the lines.

Use the tip of a no. 2 round to bring some leaves out from the basket with Hauser Dark Green.

15 The flowers in the baskets are dabs of different blends of colors. I used Honey Brown and Primary Yellow. Dab the flowers on with the tip of a no. 2 round in the same way you dabbed on the leaves. Add some Country Red + a touch of Primary Yellow to make a deep orange. Mix a light yellow with Primary Yellow + Warm White. Try to keep the red mostly on the left side of the plant and place the lighter colors on the right. This placement will help give the plant depth and shape.

Details

1

2

3

4

Tree

1 Use a scruffy flat and pounce Georgia Clay onto foliage area. Basecoat the lower part of the trunk with Neutral Grey using a no. 1 round. Paint the upper trunk and branches with Graphite + Ebony (Lamp) Black (2:1). Use the no. 6/0 scroller for branches, starting your stroke at the trunk and stroking outward. Use less pressure as you bring the stroke outward. This will make your line thinner, and your branch width will taper off as it does in nature. Use a no. 6 flat to float this dark color down the left side of the trunk for shading.

2 Again with the flat scruffy, pounce more Georgia Clay onto the foliage area covering some of the trunk. Work in clumps to help keep the tree realistic. Pounce Marigold + Cocoa (1:1) onto the foliage, making sure the Georgia Clay shows through. Dry brush Grey Sky onto the trunk with a small round scruffy.

3 Pounce Marigold onto the foliage over the previous gold mix, but don't cover it. Apply Black Green on the grass under the tree for the bench's shadow. Paint the very bottom of the trunk Ebony (Lamp) Black, since it will be shaded by the bench. Paint the bench Warm White with a no. 3/0 round. Two coats may be required.

4 With the small scruffy, pounce Warm White + Marigold (2:1) for the lightest leaves. Use a smaller round brush to dab points of color (to simulate leaves) around the tree foliage. Use all the colors you used for the foliage in steps 1–3. Add watery black shading on the tree trunk under any leaves painted in front of the trunk. To shade the bench, add a touch of Ebony (Lamp) Black to the Warm White to make a light gray. Shade around the edge and legs on left and the tops of legs.

Chickens

1 Undercoat the chicken with Snow (Titanium) White with a no. 1 round. Shade the ground under the chicken with Avocado.

2 Paint most of the left side and the shaded areas on the chicken with Antique White and the no. 1 round. Paint the legs and beak with Marigold.

3 Switch to a no. 2 round and stroke Snow (Titanium) White over the rest of the unpainted areas. Use Antique White + a touch of Camel to create the wing detail.

4 Add the comb with a no. 1 round and Country Red. There is no need to fuss with a lot of details in the chickens—they are very small.

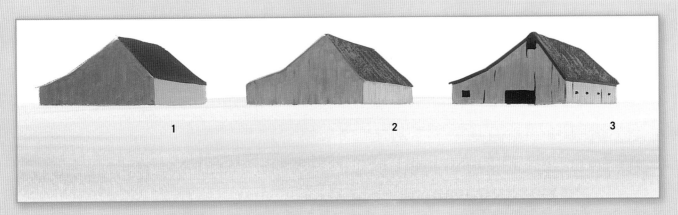

Distant Barn

1 Paint the barn Grey Sky and the roof Terra Cotta. Mix Grey Sky + Ebony (Lamp) Black (4:1) and make a watery wash, then use a no. 2 round to stroke this mixture onto the shaded side (the left side) of the barn. Brush it on so you are left with vertical streaks.

2 Place a watery wash of Warm White on the right side of the barn, again allowing vertical streaks to form. Mix Warm White + Terra Cotta (2:1) to make a beige. Use a no. 1 round and drybrush this mixture onto the roof, following the angle of the roof.

3 Use a no. 6/0 scroller to run a line of shadow under the eaves in Graphite. Add a touch of Ebony (Lamp) Black to the Graphite and add the door and window openings with a no. 0 round. Use just the tip of the scroller to add cracks in siding and the side windows.

Quilt

Use a no. 3/0 round and no. 2 flat to paint the blocks in the quilt. You can use your own colors and design, but the colors I used here were Light Avocado, Celery Green, Evergreen and Marigold. Paint the larger blocks and the lines and border last. Where the sun is hitting the quilt, draw a diagonal chalk line for a guide. Then add one part Snow (Titanium) White to one part of the color you need to lighten the color. For instance, where there is Marigold above your chalk line, paint it over with the lighter yellow made from Marigold + Snow (Titanium) White (1:1). The underside of the quilt is white, with a bit of Grey Sky for shadow.

Bittersweet and Near Branch

Paint the leaves on the bittersweet and near branch following the instructions on foreground leaves (page 18). The berries are formed with the dip dots technique (page 13).

29

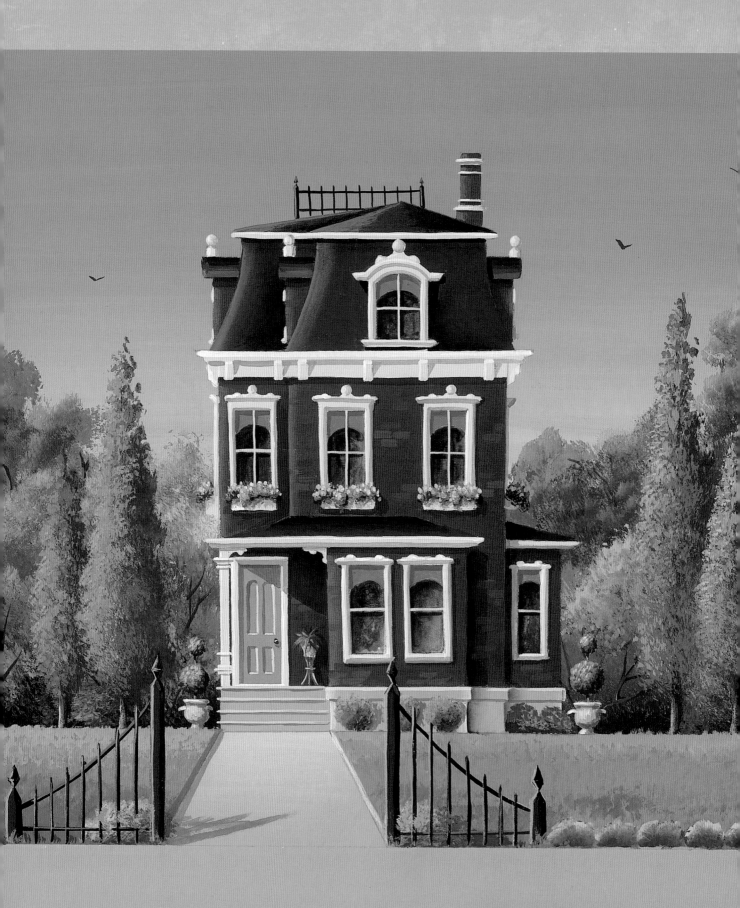

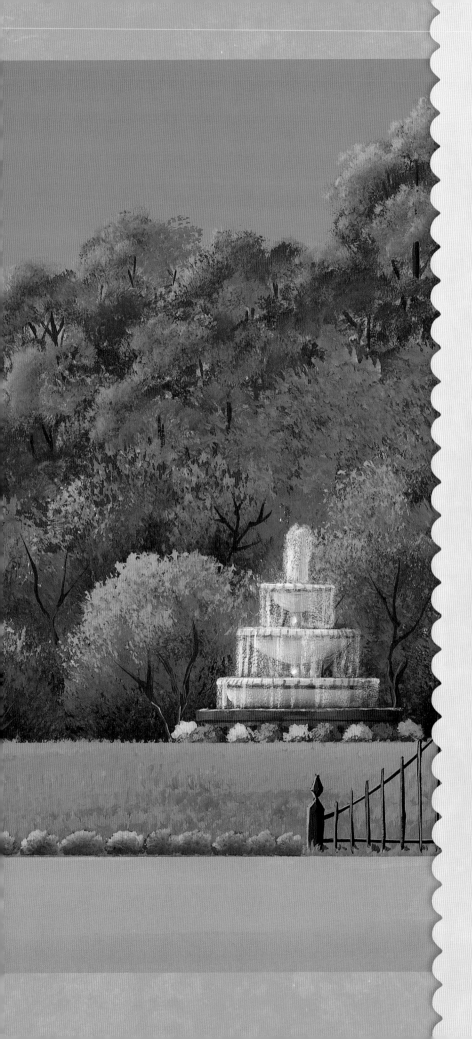

Italianate Cottage

Drive down a street

in any historic neighborhood and
you're likely to find a brick home
in the stately Victorian Italianate
style. Many are very large homes,
but there are smaller scale cot-
tages like this one, still character-
ized by their emphasized eaves,
large corbels and mansard roofs.
I chose an autumn setting for this
project, because the brick brings
out the fiery colors of the early
fall foliage.

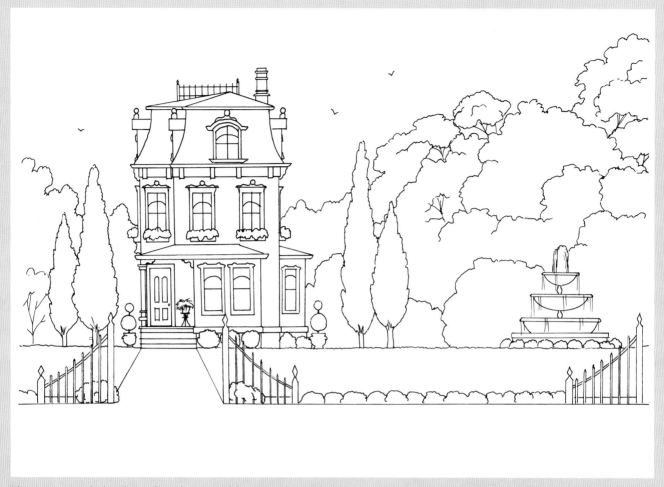

This pattern may be hand traced or photocopied for personal use only. Enlarge at 192% on a photocopier to bring it up to full size.

Sky and Foreground

The sky is Calypso Blue gradated down to the horizon. Add Snow (Titanium) White to the Calypso Blue to lighten it as the sky nears the horizon (which lies approximately even with the porch).

Paint the grass with Avocado and add some Evergreen to the Avocado as you move closer to the sidewalk (see page 19).

The sidewalk and road are Driftwood; starting at the steps use a 2:1 mixture of Driftwood and Snow (Titanium) White. Gradually eliminate the Snow (Titanium) White in the mixture and finish with straight Driftwood. Use a wash of Mississippi Mud to create the cast shadow caused by the fence post.

Background Foliage

Paint the background trees by layering clumps of greenery, first against the sky (let blue show through), then make them larger as you get near the grass. Use a smaller scruffy brush at the top and larger scruffy brushes when you make larger trees. Pounce the trees in just as you do bushes (see page 17). Tip the brushes with shades of Cadmium Orange, Marigold and Heritage Brick toward the sunlit sides.

Materials

DecoArt Americana Acrylics

Antique Maroon

Avocado

Black Green

Burnt Sienna

Cadmium Orange

Calypso Blue

Dark Chocolate

Driftwood

Ebony (Lamp) Black

Eggshell

Evergreen

Gingerbread

Graphite

Hauser Dark Green

Hauser Light Green

Hauser Medium Green

Heritage Brick

Honey Brown

Light Buttermilk

Lavender

Marigold

Milk Chocolate

Mississippi Mud

Neutral Grey

Primary Yellow

Prussian Blue

Slate Grey

Whites

Snow (Titanium) White

Brushes

Nos. 2, 4, 6, 8 and 10 flats
Nos. 3/0, 0, 1 and 2 rounds
No. 6/0 scroller
Small and large scruffy brushes
Nos. 0 and 1 liner

Additional Materials

Masking film
Craft knife
Natural sponge
Soapstone pencil or chalk
T-square
Pencil
Liquid Shadow©
Painters' tape
¼-inch (6mm) quilters' tape
Toothpick

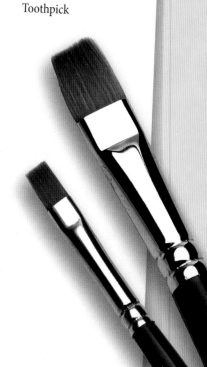

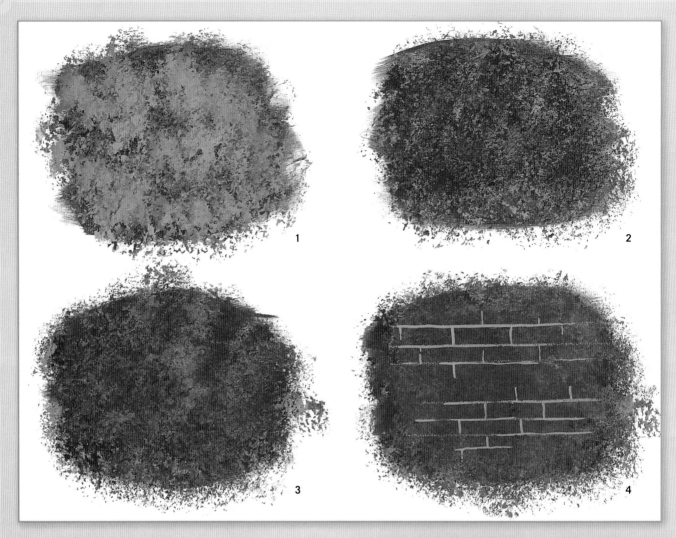

1

2

3

4

How to Paint the Illusion of Brick

1 Basecoat Burnt Sienna. Sponge on Driftwood and Dark Chocolate.

2 Sponge on Heritage Brick, but allow the other colors to show through.

3 Immediately use a clean, wet sponge to blend the colors. Let dry.

4 Chalk in the bricks. Use a no. 0 liner and Driftwood to stroke in mortar lines. The lines can be placed randomly, but it is important to make them parallel and straight up and down.

Painting the House

1 Transfer the pattern. Place masking film over the entire house. Use a craft knife to cut around all of the windows, the roof and the door. Remove the masking film covering the brick.

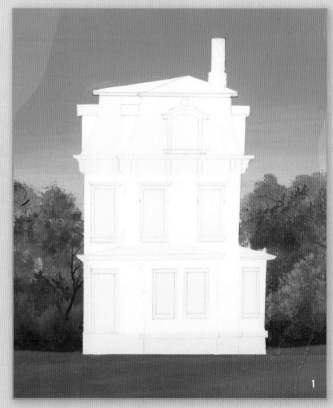

1

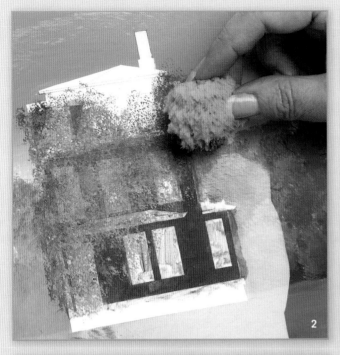

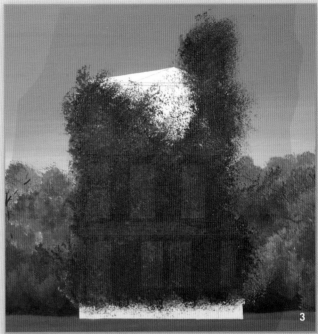

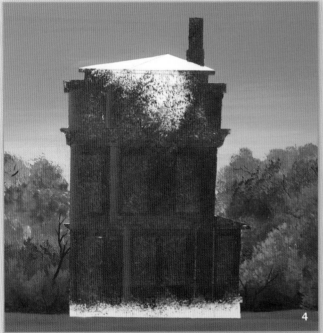

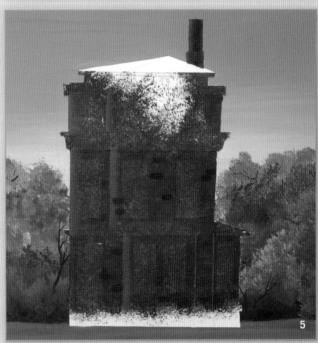

2 Basecoat the brick area with Burnt Sienna. Use only one coat. It doesn't matter if your base is streaky. With a damp natural sponge, apply Driftwood and Dark Chocolate.

3 While the Driftwood and Dark Chocolate are still wet, sponge on Heritage Brick, but allow the other colors to show through. Immediately use a clean, wet sponge and pounce lightly to blend the colors. Let dry.

4 Remove the masking film from around the house. Use a soapstone pencil or chalk and a T-square to reestab-lish the lines of the exterior walls. With a no. 10 flat, float Gingerbread along the left side of these exterior corners. This float also goes on the two left dormers. With a no. 6 flat, float Gingerbread on the left side of the chimney.

5 For the lighter bricks, mix varying values of Ginger-bread and Heritage Brick. Use a no. 2 flat to stroke in brick shapes. Also use a light wash of Antique Maroon to create bricks. Mix varying values of Antique Maroon and Heritage Brick for the darker bricks. Make sure the bricks are staggered and random to create a suggestion of brick.

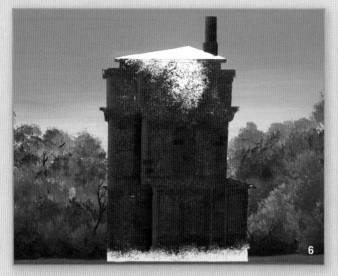

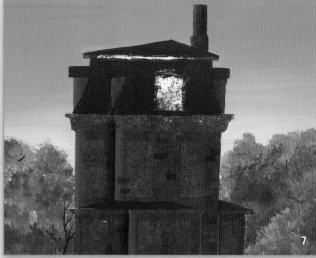

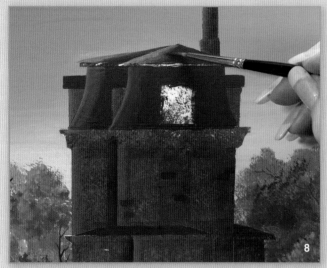

6 With a no. 10 flat, float Antique Maroon on the left side of the Gingerbread floats from Step 4. Together, the two floats become a highlight and a shadow and create the illusion of an outside corner. With the no. 6 flat, float Antique Maroon along the right side of the chimney.

7 Remove the masking film from the mansard roof, but leave the masking on the trim and window in place. With a no. 2 round, outline the roof with Graphite. Then fill in the roof with a no. 6 flat and Graphite. You will probably need to apply two coats of Graphite for full coverage. Also remove the masking film on the porch roof and roof of the window on the right side of the house. Paint these as you did the mansard roof. It may be helpful to tape off the area around these roofs so you don't paint over the brick or background.

8 With a no. 10 flat, float a mixture of Slate Grey + Graphite (1:1) on the left sides of the mansard roof. Use a soapstone pencil or chalk to reestablish the pitch line on the mansard roof. Use a no. 2 round to stroke in the gray float mixture along the top of the roof and immediately blend it into the Graphite with a clean, wet brush. If it doesn't blend well, pick up a little pure Graphite to blend the colors.

9 Float the gray mix onto the bottom half of the dormer roofs. Use a no. 2 round to stroke the gray mix along the left edge of the porch roof and blend the color into the Graphite as you did on the mansard roof in Step 8.

With the no. 10 flat, float Ebony (Lamp) Black on the roof up against the left side of the middle dormer. Float Ebony (Lamp) Black on the right side of the front-facing dormer. Use a no. 2 round to stroke Ebony (Lamp) Black along the right side of the mansard roof and blend it into the Graphite with a clean, wet brush. Do not let the Ebony (Lamp) Black shadow touch the gray mix highlight on the left side of the roof. Float black against the top of the porch roof and the tops of the side dormers. Add Ebony (Lamp) Black to the roof of the side window.

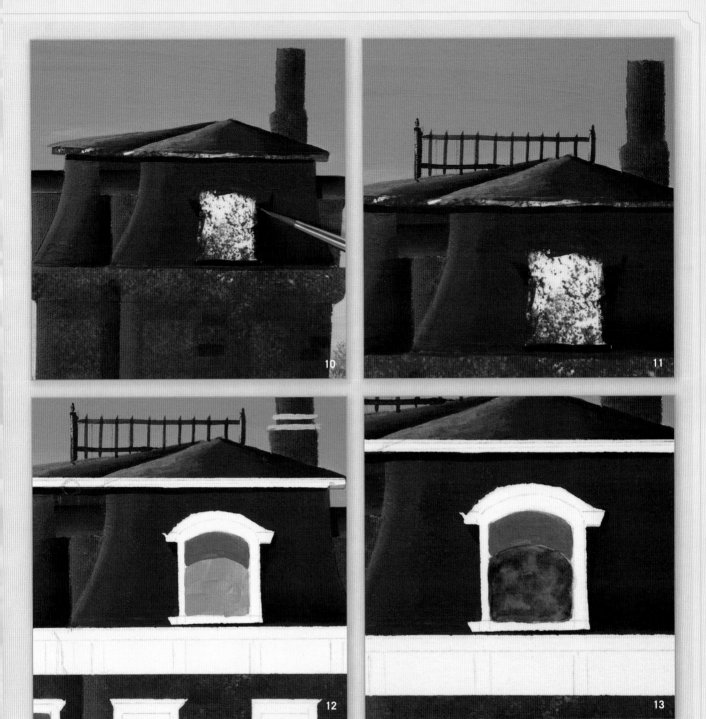

10 Load the no. 6/0 scroller with Ebony (Lamp) Black and run a line of shadow under the top trim. With a no. 2 round, place a shadow on the right dormer, under the front dormer window and under the trim on the front dormer.

11 Use a pencil and T-square to draw in the widow's walk. Paint the widow's walk using Ebony (Lamp) Black and the no. 6/0 scroller. Start the scroller at the top of the post and work down to create nice points on the posts. Switch to a no. 3/0 round to paint in the corner posts. Highlight the left side of the corner posts only with Slate Grey.

12 Remove the masking film from the trim and all of the windows. Basecoat the window shades with two coats of Neutral Grey and a no. 2 flat. Basecoat below the window shades with one coat of Calypso Blue using a no. 6 flat.

13 Dampen the Calypso Blue with clean water and a no. 4 flat. Load some Payne's Grey onto the no. 4 and dab it onto the Calypso Blue.

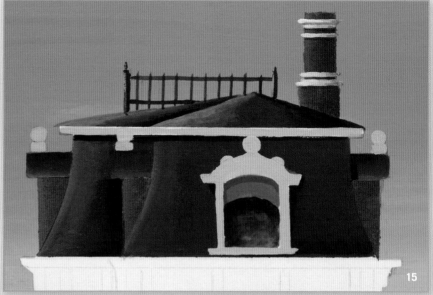

14 With a no. 6 flat, float Prussian Blue along the bottom of the gray blind and along the left side of the window beneath the blind.

15 Mix Graphite + Neutral Grey (1:1) and with a no. 1 round run a shadow along the top of the window blind and along the left side.

Use a soapstone pencil or chalk to add the trim lines to the chimney. Paint this trim with Eggshell using the no. 3/0 round. Highlight the trim with Light Buttermilk. Shade the trim with Honey Brown on the right side. Apply a thin line of Antique Maroon shadow under the trim with the no. 3/0 round. With a pencil, draw in the finials. Basecoat the trim and finials on the mansard roof with Eggshell and the no. 2 round.

16 Chalk in the window panes using a T-square. Paint the trim between the panes with Eggshell and a no. 2 round. To preserve your pattern lines on the molded trim between the brick and the roof, paint the lines with Honey Brown on the side of the line that would have a shadow (to the right and underneath). Let dry. You could use a heavy pencil line, however the lines will smear when paint is applied over them. Tape off this trim and basecoat it with Eggshell.

17 Remove the tape and touch up any bleed. Add the bottom of the corbels. Shade the trim with Honey Brown and the no. 1 round, going back over the lines you painted in Step 16. Add shadow on the right side of the window trim only on the gray window shade.

18 Highlight the trim with Light Buttermilk and the no. 3/0 round. You don't need to highlight the bottom trim on the second-story windows because it will be covered by flower boxes. Dab in the trim on the far left-side dormer with Light Buttermilk and a no. 3/0 round. Use Honey Brown to dab in the trim on the far right-side dormer.

19 Shade the brick under the eaves on the side dormers and under the trim with Antique Maroon and the no. 1 round. Also shade along the right side of the windows and under the windows. Remove the masking film from the trim on the porch roof and the door area. Paint this trim following the instructions in Steps 16–18. With a T-square and pencil, mark off the cast shadow under the porch roof. Mix Antique Maroon + Liquid Shadow© (1:1) and use a no. 4 flat to paint this shadow area. With the same mixture and brush, paint the right side of the front bump-out and the left side of the side bump-out. Let dry (this will take a little longer because the Liquid Shadow© is glaze-based).

20 Tape the sides of the door with ¼-inch (6mm) quilters' tape. Use a no. 6 flat to basecoat the lower part of the door with Honey Brown. Use a no. 2 round to apply Milk Chocolate to the upper, shaded part of the door. Both colors will require two coats for full coverage.

21 Use a T-square and pencil to draw in the door panels. With the no. 6/0 scroller and Milk Chocolate, run a line of shading down the left side of the door and along the top and the left side of each panel. Where the right panel meets the door shadow, shade the upper edge of that panel with Antique Maroon. Place a highlight of Honey Brown + Eggshell (1:1) along the right side and the bottom of each panel with the no. 6/0 scroller. If a stroke on a panel is too fat or too wobbly, pick up some Honey Brown on the no. 6/0 scroller and adjust the line. Use a toothpick to dot on a doorknob with Antique Maroon and highlight with Snow (Titanium) White.

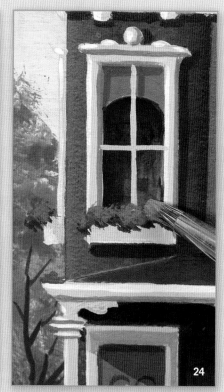

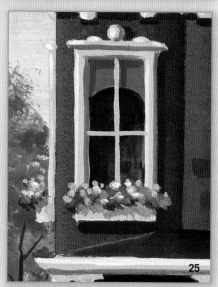

22 Use a no. 2 flat to stroke in Ebony (Lamp) Black + Liquid Shadow© (1:1) in the upper right-hand corner of the porch to intensify the shadow. Also run this shading color down the right side of the front bump-out and the left side of the side bump-out. Then take a clean brush and soften the edge of this shading line. Mix Honey Brown + Eggshell (2:1) and shade the upper trim on the porch roof. Shade the top of the door with Milk Chocolate + Antique Maroon (1:1) and the no. 6/0 scroller. Load the no. 6/0 scroller with Eggshell and highlight the shaded trim.

23 Run the trim shading (Honey Brown + Eggshell [2:1]) along the upper edge of the trim and the side of the porch post. With the no. 6/0 scroller run Antique Maroon down the right side of the door frame to shade the brick. Add a little bit of Ebony (Lamp) Black to the Antique Maroon in the shaded area of the door frame.

24 With a no. 3/0 round and Eggshell, add the frame of the second-story window on the left (unseen) side of the house. Use the same brush to highlight with Light Buttermilk. Mix Black Green + Avocado (1:1) and use a very small scruffy brush to pounce on some dark foliage in the flower box. With the same brush, pounce on Avocado + Hauser Light Green (1:1) just above and on top of the dark foliage.

25 Load a no. 1 round with Honey Brown and dab it on the flower box just beneath the dark foliage for shadow. Use the same brush to dab on little round dots of Light Buttermilk on the foliage as an undercoat for the blooms. Load the brush with Primary Yellow and place the color on the dots. Then mix the Primary Yellow with Honey Brown and add it to some of the blooms for varying yellow colors.

Details

Stairs

The foundation, stairs and sidewalk are all basecoated with a mixture of Neutral Grey + Snow (Titanium) White (2:1). Use a chalk pencil to mark off the steps in four equal parts, and use a no. 6/0 scroller to highlight the steps with a 1:1 blend of the base color grey mix and Snow (Titanium) White. (This high-

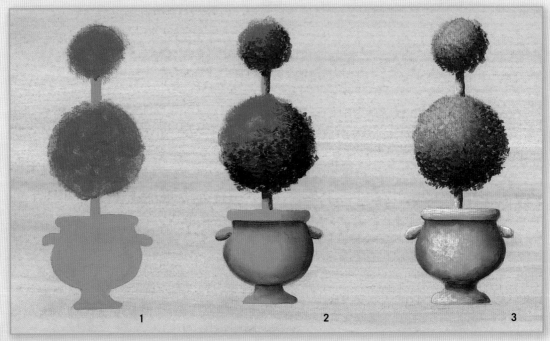

light is also used on the foundation). Shade the steps in the same way using Mississippi Mud.

Fern in Stand

Use a no. 3/0 round to paint the plant stand Honey Brown, and highlight it with a lighter mix of Honey Brown + Snow (Titanium) White (1:1). Use the same brush to stroke in leaves of Evergreen on the right, and Evergreen + Snow (Titanium) White (2:1) on the left for highlight. Be sure to make the shadow of the fern and stand to the right of it on the brick wall.

Chrysanthemums

The small bushes in the front of the house and the chrysanthemums and the border plants at the sidewalk are all pounced on as directed on page 17. Use Marigold to tint the bushes, and Lavender for the purple flowers. Highlight the Lavender by adding one part Snow (Titanium) White to it. Do the same with the Marigold for the yellow flowers. Be sure to use more highlight on the flowers on the left side of the fountain, which gets more sun.

Cedar Trees

See page 101 for instruction on painting the cedar trees next to the house.

Topiaries

1 Paint the urn and trunk Slate Grey with a no. 4 flat. Use a small scruffy to pounce Hauser Medium Green onto the topiary.

2 Pounce Hauser Dark Green around the lower left side of the topiaries. Mix Hauser Medium Green + Hauser Dark Green (1:1) and pounce between the light and dark areas to blend. Use a no. 8 flat to float Graphite onto the urn for shading. For handles, brush on Graphite with a no. 3/0 round and blend into the base color with a clean, wet brush. Shade the right side of the trunk and under the foliage with the same brush and Graphite.

3 With a flat brush, dampen the left side of the urn with clean water. Use a small round brush and dab a little watery Snow (Titanium) White onto this area. It should look thin and splotchy. Let dry. Dab this thin white onto other areas needing highlight. Use a stronger white and dab on more highlight, including the left side of the trunk. Mix Hauser Light Green + Snow (Titanium) White (1:1) and pounce this color onto the upper left sides of the topiaries. Remember, it is very important to keep the highlighted and shaded areas separated. The base color of the topiary must show between the two in order to show depth and shape.

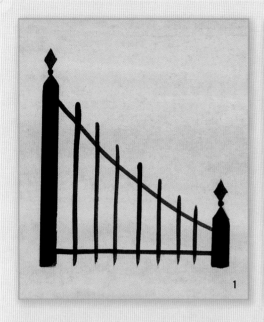

Fence

1 Mask off the posts with tape to ensure straight lines. Paint the thin fence posts with Ebony (Lamp) Black with the no. 6/0 scroller. Use a no. 0 round to paint the large posts and finials.

2 Use the same brushes to apply the highlight to the left sides of the posts using a mix of Slate Grey + Snow (Titanium) White (1:1).

Fountain

1 Basecoat the fountain with Slate Grey. Basecoat the brick foundation with one coat of Heritage Brick. Don't worry about streaks in this coat of Heritage Brick.

Use a no. 6 flat to float Graphite along the right side of the fountain's top tier. Use a no. 8 flat for the middle and bottom tiers. Use a no. 2 flat to float Graphite onto the right sides of the center supports between the tiers.

Paint Antique Maroon onto the right side of the foundation and blend it to the left into the Heritage Brick color.

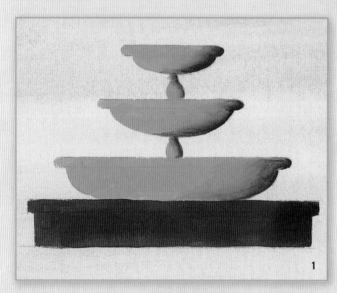

2 Using the same brushes where indicated above, float highlights with Titanium White onto the left side of the fountain.

Mix Titanium White + Gingerbread (1:1) and paint this mixture on the left side of foundation. While this is still wet, add a little Gingerbread to the right edge of the wet paint and blend toward the center of the brick foundation.

Use a no. 2 flat to stroke thin washes of Gingerbread and Antique Maroon onto the foundation to simulate bricks. It is not necessary to go to the ground since this will be covered by flowers later. Make the brick strokes vertical along the upper edge of the foundation. Make all the strokes mainly on the left side.

Drybrush Titanium White along the upper edges of the fountain's tiers to create rims and under the vertical bricks on the foundation.

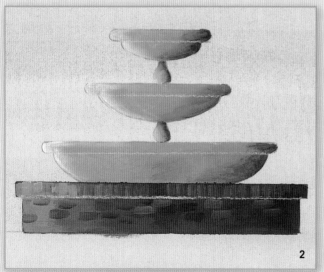

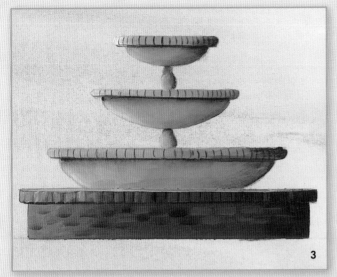

3

4

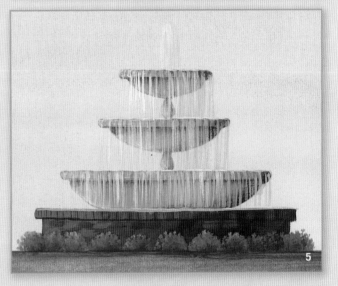

5

3 Use a no. 4 flat to float Graphite along the lower edge of the rims of the fountain. Use a no. 1 liner to stroke an Antique Maroon shadow under the edge of the vertical bricks on the foundation. Stroke vertical lines between the bricks on the edge. Mix Gingerbread + Snow (Titanium) White (1:1) and stroke highlights along the upper edge of the foundation. Use a no. 1 liner and thinned Graphite to stroke in grooves onto the rims of the fountain. Start in the center and work outward, slightly arching the strokes. As you near the edges, make the lines closer together to give the illusion of perspective and depth.

4 Pencil in a light guideline ¾-inch (19mm) high from the fountain's top tier. This will be your guide for the spray of water, and the line will be covered as you paint over it. Tape off the upper tier to protect it.

Mix Snow (Titanium) White and Calypso Blue (2:1) and use a no. 1 round to drybrush strokes of water against the right side of the guideline. Make the top of this waterspout rounded. Remove the tape and move it down to cover the middle tier.

Use a ½-inch (13mm) rake brush and with the same blue mix stroke vertical streaks of cascading water from the upper tier down to the tape. (When using a rake brush, be sure the paint is very watery.) Don't cover the fountain tier entirely—make these strokes very sparingly and be sure your strokes are straight and vertical. Apply this color only to the right side of the fountain.

Move the tape again and cover next tier. Repeat the above steps for the center and bottom tiers. When painting on the bottom tier make sure you mask off the foundation.

5 Repeat Step 4 for the water on the left side using pure Snow (Titanium) White. Make sure the paint is very thin and translucent. Carry the white strokes over the blue just a bit to overlap colors.

Use a no. 1 liner with a thicker Snow (Titanium) White and stroke vertical streaks of highlights into the blue water on the right. Make tiny dashes of Snow (Titanium) White along the top rims of each tier where the water spills over.

Complete the flowers as shown on page 53 in the *English Country Cottage* project.

English Country Cottage

This little thatched roof cottage is one of my favorite things to paint. The tranquil English setting, abloom with color, evokes a bygone time of warm lazy days in the peaceful countryside.

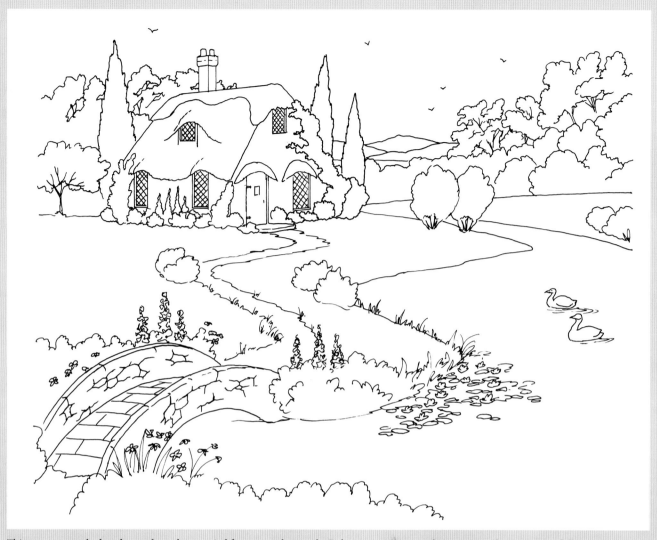

This pattern may be hand traced or photocopied for personal use only. Enlarge at 185% on a photocopier to bring it up to full size.

Materials

DecoArt Americana Acrylics

Admiral Blue

Avocado

Baby Pink

Bittersweet Chocolate

Black Green

Bleached Sand

Burnt Sienna

Burnt Umber

Butter

Dark Chocolate

Deep Periwinkle

Ebony (Lamp) Black

French Grey Blue

Grey Sky

Graphite

Hauser Dark Green

Hauser Light Green

Honey Brown

Lavender

Light French Blue

Marigold

Neutral Grey

Prussian Blue

Sable Brown

Soft Lilac

True Red

Vivid Violet

Whites

Snow (Titanium) White

Brushes

Nos. 2, 4, 6, 10 and 14 flat
No. 6/0 scroller
Nos. 3/0, 1 and 2 rounds
⅜-inch (10mm) comb
Small scruffy
½-inch (13mm) and 1-inch (25mm) mop
½-inch (13mm) dome

Additional Materials

Masking film
Craft knife
Facial tissue
Pencil
Liquid Shadow©
Blending gel
Rubber band stippler

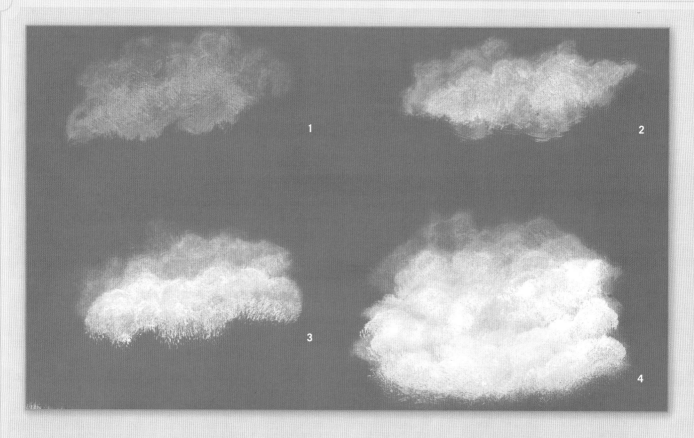

Sky and Clouds

Base the sky with a mixture of Snow (Titanium) White + Admiral Blue (3:1) using a large flat brush. Gradate the color by adding more white as you near the horizon, making long, horizontal strokes.

1 To create the clouds, mix blending gel + sky color (3:1). Use a ½-inch (13mm) mop brush to pounce this mixture onto the sky, working in small areas at a time. Start up where the sky will peek through and work down. Use a dry ½-inch (13mm) dome brush (or small mop) to make very small swirls at the cloud's edge to give it a transparent, fluffy appearance. This is especially important against the blue of the sky. Wipe the brush on paper towel often to keep it as dry as possible. Don't worry about mopping out the bottom edge of the cloud. Let dry.

2 Pick up more Snow (Titanium) White and repeat Step 1, only lower in the sky—below the cloud you made in Step 1. Make the edge irregular and fluffy as before, taking care not to follow the contour of the first cloud.

3 Continue making random layers of clouds until you reach the horizon. Make the final clouds smaller (narrower) at the horizon since they would be farther in the distance.

4 Use straight Snow (Titanium) White for the final clouds, again, making them lower than the others and bring them down to the horizon. Let dry. Paint a thin film of blending gel onto the clouds. Use a flat brush to stroke in areas of Baby Pink and Soft Lilac. Use a large mop brush to move these tints around the clouds, with more pink in the upper left areas. Let dry. Add a few Snow (Titanium) White highlights onto the clouds on top of the pink and lilac tints.

Mountains

Use a no. 4 flat to paint distant mountain in Light French Blue + Snow (Titanium) White (1:1). The mountain to the left is a mix of French Grey Blue + Snow (Titanium) White (1:1), and the nearest mountain is French Grey Blue.

Background Foliage

1. Make the tallest trees first, pouncing on mixes of green with a scruffy brush, then paint the tall flowering bushes following the instructions on page 17. Stroke in trunks and branches with Bittersweet Chocolate.

2. Use a small scruffy to pounce in varying shades of greens. Work in clumps, and take care not to make round balls for trees. They need to be ragged and natural looking. For these trees, which are growing close together, you shouldn't be able to discern one tree from the one next to it.

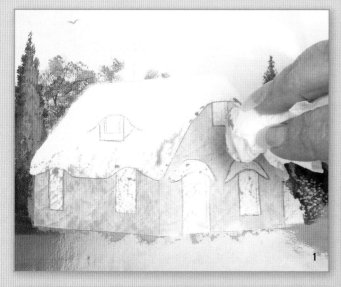

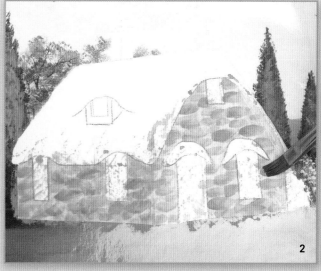

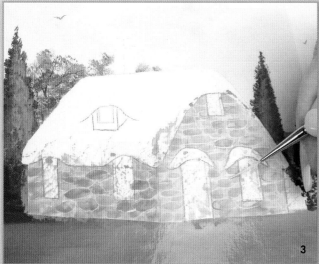

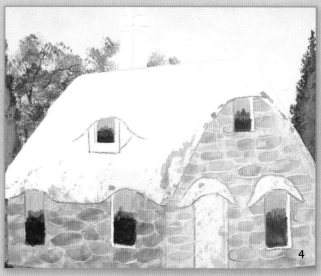

Painting the House

1 Place masking film over the house and use a craft knife to cut out the roof, windows and door. Remove the mask from the exterior walls. Wet the walls with clean water using a no. 10 flat. Mix Snow (Titanium) White + Neutral Grey (2:1). Make the mix very watery and dab it on to the wet paper. Crumple up a facial tissue so it is very wrinkled and lift away some of the color to create a mottled effect.

2 With a no. 6 flat, stroke in different sized stones in varying shades of Snow (Titanium) White + Neutral Grey.

3 Make a wash of Snow (Titanium) White and go over the sunlit side of the cottage (the right side). Let dry. With a no. 6/0 scroller and very watery Snow (Titanium) White, draw grout lines in very random areas. The stones should be different sizes and are not evenly staggered as bricks

are. Follow the strokes that you made in Step 2 and fill in anything in between. Use just the tip of the brush to create a very fine line. It's not necessary to go all the way to the ground because there will be foliage covering the bottom of the cottage.

4 Remove the masking film from the windows. Mix Snow (Titanium) White + Admiral Blue (2:1) and paint the top halves of the windows with the no. 2 round. On the front windows, use Avocado to paint in the bottom halves of the windows and blend it into the light blue while both colors are still wet.

On the left-side windows use Black Green + Avocado (1:1) to paint in the bottom halves of the windows. Blend the green mixture into the blue mixture while both are still wet.

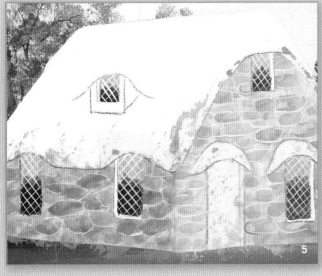

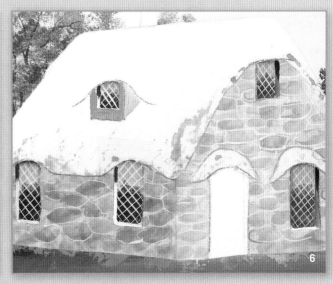

5 Load a no. 6/0 scroller with Snow (Titanium) White and paint the leaded glass lines on the windows. (Remember, when loading scroller and liner brushes use paint that is very thin with water.)

6 Side load a no. 6 flat with Prussian Blue and float the color on the left side and the top of the windows on the front of the house.

Switch to a no. 1 round. On the front of the house, the right, inside edge of the window is Neutral Grey. But at the top where the window is shaded by the overhang, make the edge Ebony (Lamp) Black and blend it into the Neutral Grey.

On the left-hand side of the house, make the left inside edges and the windowsills Snow (Titanium) White.

The left side of the dormer is Neutral Grey + Snow (Titanium) White (1:1). The right side is Snow (Titanium) White + Neutral Grey (2:1).

7 Mix Honey Brown + Snow (Titanium) White (2:1) and paint the door with a no. 6 flat. Shade the inside of the door frame with Neutral Grey using the no. 1 round and switching to Ebony (Lamp) Black where the frame is shaded by the thatch. Shade the right side of the door with a very watery wash of Dark Chocolate + Honey Brown (1:1).

8 Load the watery Dark Chocolate + Honey Brown mixture on the no. 6/0 scroller and pull out cracks in the door. Where those cracks go into the dark shade, paint the cracks Burnt Umber.

Pencil in the door window and paint it with Admiral Blue at the top and Avocado at the bottom. Blend the two colors together. Outline the frame on the left and lower side with Raw Umber and highlight it on the upper and right side with Honey Brown + Snow (Titanium) White with the no. 3/0 round. Add the hardware and doorknob with Ebony (Lamp) Black and the no. 3/0 round.

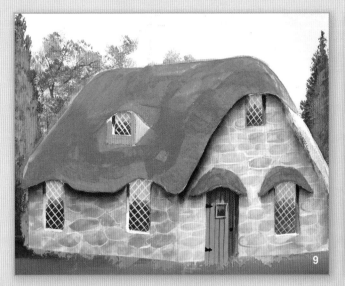

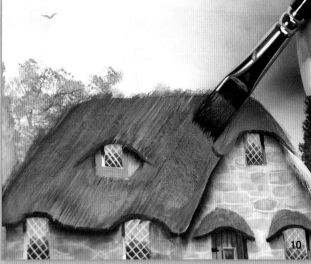

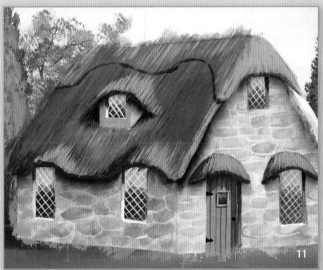

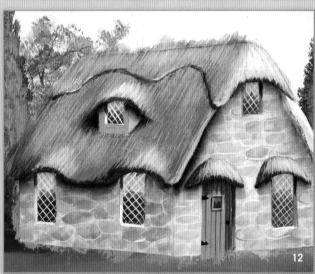

9 With a no. 6 flat, float Bittersweet Chocolate at the top of the door against the overhang for deeper shading.

Remove the masking film from the roof. Basecoat the roof with Honey Brown and the no. 10 flat. You don't need to paint the far right side of the roof because it will be covered by the climbing roses. Use a no. 1 round to paint the overhangs. Let dry.

Float Ebony (Lamp) Black beneath the eaves using the no. 14 flat on the left side and a no. 10 flat on the right side. Be sure not to float over the windows. Only float on the stone. Also float the Ebony (Lamp) Black beneath the overhangs and the upper dormer where it would be shaded by the overhang.

10 Run Burnt Umber against the bottom edge of the eaves and roof with a no. 1 round. Load a ⅜-inch (10mm) comb with very thin mixtures of various values of Sable Brown + Honey Brown + Butter + Dark Chocolate.

(You must work with very thin paint so the color comes off the end of the comb bristles individually.) Paint over the roof using short, choppy strokes and make sure the strokes follow the angle of the roof's pitch. The bristles of the comb brush help create the appearance of thatch.

11 Stroke in the lap line on the thatch with a no. 3/0 round and Burnt Umber. Use short, choppy strokes of the no. 3/0 round and Burnt Umber to define and shape the overhangs. Add Ebony (Lamp) Black to the Burnt Umber and intensify the deeper shadows.

12 Use the no. 3/0 round to paint highlights onto the lap line with Butter. Alternate between the ⅜-inch (10mm) comb and no. 1 round to add more color to the straw using various values of Honey Brown + Butter.

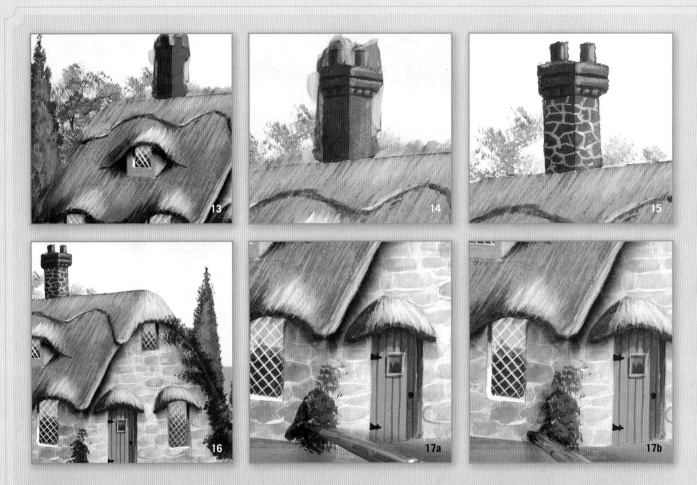

13 Shade to the left of the overhangs with Burnt Umber and just a few strokes of Lavender with the no. 1 round.

Remove the masking film from the chimney. Basecoat the chimney with Burnt Sienna using the no. 2 flat. Let dry.

On the shaded side (left side) apply a wash of Burnt Umber with a no. 6 flat. On the right side apply a wash of Burnt Sienna + Snow (Titanium) White (2:1).

14 With the no. 1 round, shade the detail on the left side of the chimney with Burnt Umber + a touch of Ebony (Lamp) Black. On the right side, shade the detail with Burnt Umber. Now, add more Snow (Titanium) White to the Burnt Sienna + Snow (Titanium) White mixture from Step 13 and highlight the right side.

15 For the chimney mortar on the shaded side (left side), load the no. 6/0 scroller with Sable Brown + Snow (Titanium) White (1:1). Sketch in mortar lines with the very tip of the scroller on the lower part of the chimney. Add a bit more Snow (Titanium) White to the mix and paint mortar lines on the right side of the chimney.

16 Cutting the masking film can be tricky, and it is easy to miss your lines. After you remove your masking film, you'll sometimes need to go back and make adjustments where the masking film was cut crooked. In this case, I needed to make adjustments to the chimney.

Before you begin working on the climbing rose, use a no. 6 flat and Honey Brown to adjust any thatch that might show through the foliage.

Use a small, scruffy brush to pounce on Hauser Dark Green for the dark, shaded rose leaves.

17 With the same scruffy brush mix Hauser Light Green + Hauser Dark Green (1:1). Pounce this color on sparingly onto the foliage keeping toward the right to retain the dark foliage shadow.

Mix Liquid Shadow© + Ebony (Lamp) Black (2:1). Load a small round brush with the mixture and tap it on the house beneath the foliage, as shown in the first photo for this step.

Then rinse your brush and blend the color out into the stone wall, as shown in the second photo for this step. Blend only the outer edge of the Liquid Shadow©, and leave it full strength next to the bush. Apply the shadow to the bush on the far left corner of the house even though the sun is not striking it. This shadow will bring the bush forward and separate it from the wall.

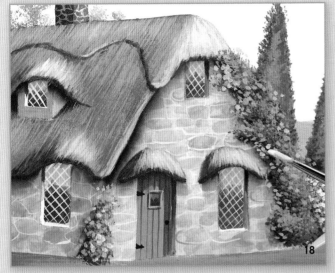

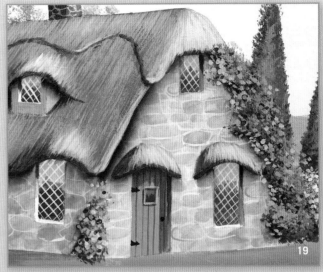

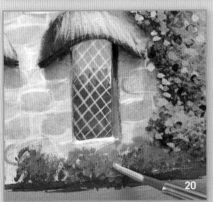

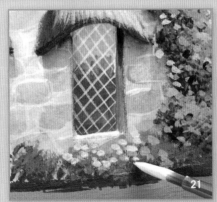

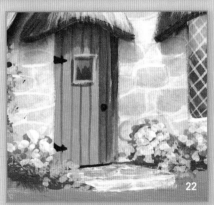

18 Mix Bleached Sand + Hauser Light Green (1:1) with the small scruffy brush and pounce the mixture very sparingly onto the right of the climbing rose bushes. Load a no. 1 round with this light green mixture and dot in individual leaves. It is especially helpful to dot these leaves over the darker foliage so they show up more. These leaves give the bush a lighter, airier look. Vary the value of this light green color as you wish by adding more Bleached Sand.

19 Use a no. 1 round to dot on undercoated roses using Snow (Titanium) White. Using a white undercoat will allow the red roses to appear more brilliant against the green foliage. Vary the sizes of your dots so the blooms don't look uniform. When dry, go over the white dots with True Red. Mix Bleach Sand + True Red (2:1) to create a medium-value pink. Dot this highlight on random roses. It doesn't matter where the highlight is on the bloom, it simply adds dimension to the blooms.

20 Mix Avocado + Hauser Dark Green (1:1). Use a no. 6 flat to sweep this color across the base of the house to give a shadowy base to the grass. Load this mixture onto a small scruffy brush and pounce in some bushes

of varying height on all sides of the house. Lighten these bushes by pouncing in some Hauser Light Green. Load a no. 2 round with color (here I used Deep Periwinkle) and dot on blooms that are close together. Cover the bush, but allow the green to show through. The other bushes are painted the same way using Vivid Violet, Baby Pink and True Red + Snow (Titanium) White.

21 Lighten up the flower color by adding Snow (Titanium) White to it. Then add even more Snow (Titanium) White and lighten the color once again on the flowers nearest the sunlight (in this case it's to the top right of the bush).

22 Paint in the step with Snow (Titanium) White. Load a no. 1 round with a very light wash of Neutral Gray and place some thin, very narrow strokes on the top of the step. Do the same on the front edge of the step but make these lines a little lighter. Paint a thin Snow (Titanium) White line along the edge of the step. Load the no. 1 round with very thin Ebony (Lamp) Black and paint the crack under the door.

Details

Pond

Water reflects what is above it, as a mirror would if you laid one flat on the floor. In this case, very little blue sky is visible, so the pond wouldn't reflect much blue. It would reflect clouds and greenery from the banks, or even the color from a flowering bush—it just depends on where you work in the painting. But I always like to use blue in my water as opposed to more green. We don't want to paint a swamp! This demonstration shows you the basics of painting a still-water pond. Where needed, add reflections of clouds or reflected flower color.

1 Use a large flat such as a no. 14 to stroke in a mixture of Snow (Titanium) White and Admiral Blue. The ratio isn't important here, just make a medium blue. Cover the entire pond down to the lily pads. Then add more Admiral Blue to the brush and bring it down to the bottom of the painting. The water color should be a bit darker than the sky, which is a 1:1 mixture of Snow (Titanium) White and Admiral Blue.

2 In this example, I have included a grassy bank, so the reflection will be mostly green. But keep in mind you will bring colors in to the water that are just above the water, depending on where you are working. As an example, the blue bushes on the right will cast a blue reflection in the water, so you will use the same paint color for both. This step simply shows you the basic strokes. The grassy bank is blends of Hauser Medium Green, Hauser Light Green, with Hauser Dark Green and a touch of Black Green at the water's edge. These colors will be in the reflection as well. Brush blending gel onto the surface of the water in a thin layer

using a large flat brush. Use a no. 10 flat to brush the greens horizontally, starting with the darkest and ending with the light farthest away from the bank. Start just at the water's edge. Switch to the ⅜-inch (10mm) comb and, starting at the top of your strokes, pull down vertical strokes through the paint, lifting your brush at the bottom to taper off. These strokes should be deeper in the water than the height of the actual bank.

3 Rinse the brush and fluff it dry on a paper towel. Now use very light pressure and make horizontal stokes across the water. Don't completely brush out the vertical strokes previously made.

4 Use the chisel edge of a no. 6 flat to draw irregular sweeping lines across the surface with watery mixes of various blends of Avocado and Snow (Titanium) White. Use the no. 6/0 scroller to draw a very thin irregular line at the bank to show a highlight at the water's edge in the same color.

Stone Bridge

Before painting the grass area around the ridge, first mask off the bridge with masking film. All flowers and the path behind the bridge should be completed before bridge is painted. See page 17 for instruction on painting flowering bushes.

1 Paint the bridge following the same techniques used for the cottage walls in Step 1 on page 49.

2 Float Graphite along the back rail and on walk. Stroke in watery Graphite or Liquid Shadow© on front for shadows of the plants that will go in later. Use watery Snow (Titanium) White to stroke along the upper side rails.

3 Paint grout lines as in Step 3 on page 49 for the house, except for the larger stones on the walk; they are squared and evenly staggered. Float watery Graphite with a no. 4 flat onto random stones to enhance them. Don't worry too much about the ends of the bridge. You'll cover those areas by pouncing on flowering shrubs and tall flowers.

Ducks

Paint the ducks using the same technique as shown for the chickens in the *Country Farmhouse* painting (page 29) except add a little Grey Sky under the wings. Be sure to stroke some white into the water for reflection.

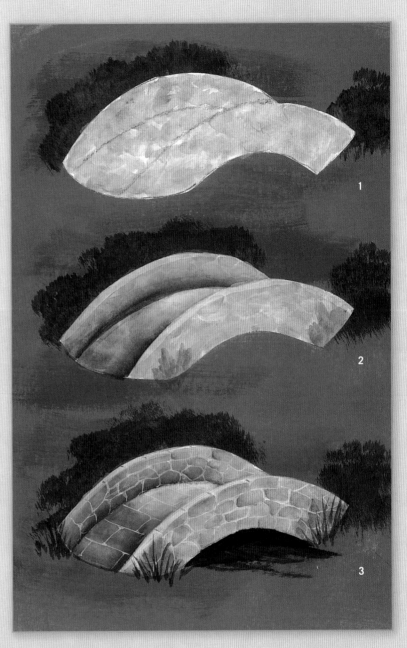

Lily Pads

1. Use the chisel edge of a no. 4 flat to stroke Avocado onto the water. You want small oblong shapes. These leaves won't have a reflection, but instead, a shadow. Make the shadow a watery Admiral Blue just underneath the leaves with the same brush.

2. For the flower, use a no. 3/0 round to make four or five tiny strokes of Snow (Titanium) White tinted with just a touch of Marigold.

Pink Dogwood Tree

The pink dogwood tree to the left of the house was made with a rubber band stippler. You can create a natural, airy stipple with this tool (see page 16 for directions on how to make your own). After stroking in a trunk and a few branches with a no. 6/0 scroller and Burnt Umber, dip the long-bristled end of the stippler in a light pink mixture of True Red + Snow (Titanium) White (3:1), then pounce lightly to make the shape of the tree. Rinse out the stippler and pounce over it again very lightly with Snow (Titanium) White.

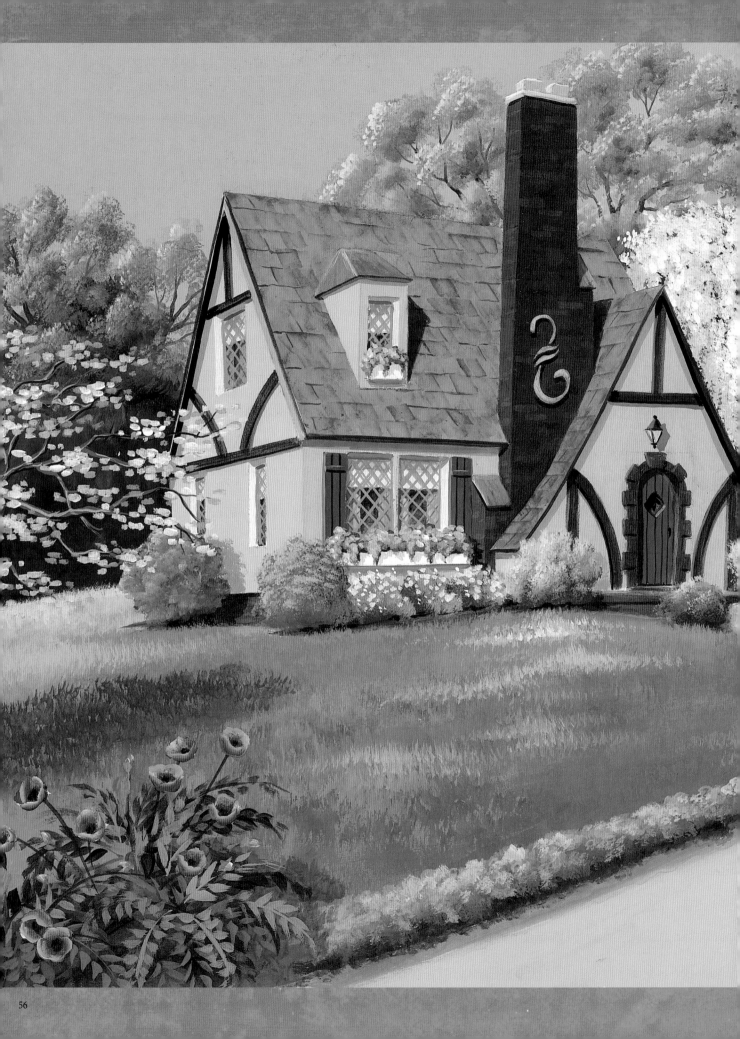

English Tudor

This sweet little
cottage is actually called a *story-book* Tudor, for obvious reasons. How charming it looks nestled amid an abundance of summer blooms!

This pattern may be hand traced or photocopied for personal use only. Enlarge at 182% on a photocopier to bring it up to full size.

Materials

DecoArt Americana Acrylics

Alizarin Crimson

Antique Maroon

Avocado

Baby Blue

Black Green

Bleached Sand

Blue Haze

Burnt Sienna

Dark Chocolate

Desert Sand

Driftwood

Ebony (Lamp) Black

Eggshell

Evergreen

Gingerbread

Graphite

Green Mist

Hauser Light Green

Hauser Medium Green

Heritage Brick

Lavender

Light Buttermilk

Marigold

Mississippi Mud

Neutral Grey

Payne's Grey

Primary Red

Prussian Blue

Raw Sienna

Raw Umber

Slate Grey

Brushes

Nos. 2, 4, 6, 8 and 10 flats

Nos. 3/0, 0, 1 and 2 rounds

No. 6/0 scroller

Mop brush

Small- and medium-size scruffy brushes

Additional Materials

Masking film

Craft knife

Metal ruler or straightedge

Painters' tape

Facial tissue

Soapstone pencil or chalk

Liquid Shadow© Pencil

¼-inch (6mm) quilters' tape

Blending gel

Natural sponge

Whites

Snow (Titanium) White

Sky and Trees

Paint the sky Baby Blue and let dry. To make a thin, wispy cloud, apply blending gel to the sky, then use a no. 8 flat to streak in just a hint of Snow (Titanium) White. Use a dry mop brush to blend it up, giving it a bit of a soft curve.

Use a scruffy brush to pounce in distant trees in shades of Hauser Light Green, Hauser Medium Green and Evergreen. Start with the lightest green at the top and work down, creating layers of trees. Add branches and trunks with Raw Umber and a no. 6/0 scroller.

Weeping Cherry

1 Mask off the roof to protect it. Use a medium scruffy and pounce Evergreen onto the center of the foliage. Use a smaller scruffy and pounce Avocado onto the outer branches.

2 Use the same small scruffy and pounce Bleached Sand onto the tree and down the hanging branches. Allow some of the green background to show through.

3 Switch to a smaller round scruffy and pounce Snow (Titanium) White onto the left sides of the blooming branches. Use the tip of the brush to dab points of Snow (Titanium) White around the edge of the tree to simulate individual blooms. Place these blooms against the sky and background trees for a soft, airy effect.

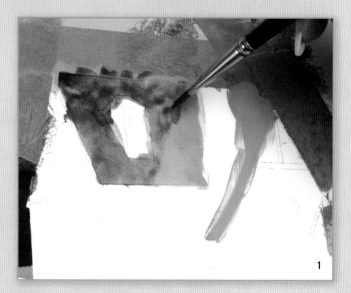

Painting the House

1 Cover the house with masking film. Use a craft knife and metal ruler to cut the windows, beams, chimney, dormer and roof. Remove the masking film only from the slate roof areas. Mask off the top of the roof with painters' tape to protect the sky and background. Basecoat the roof with one coat of Slate Grey using the no. 10 flat. Let dry.

Wet the surface with clean water using a no. 10 flat. Dab on very watery Graphite with the same brush.

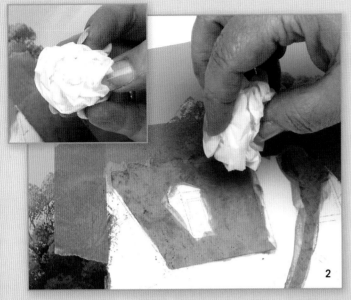

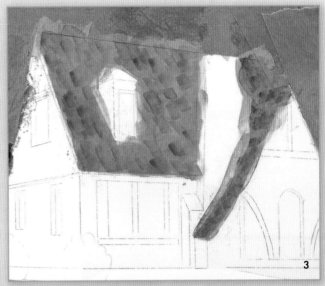

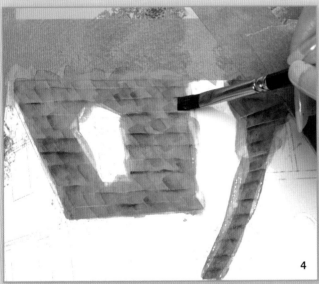

2 Crumple facial tissue as shown. You need a lot of wrinkles in the tissue for texture. Lift up some of the watery Graphite with the crumpled tissue to create a mottled effect. Let dry.

3 Load one side of a no. 6 flat with very watery Graphite. Follow the roofline and make small strokes to give the illusion of slate. It's important to change the direction of the strokes on the roof that is over the front door area.

4 Use a soapstone pencil or chalk and a straightedge and draw in some guidelines along the roof to help preserve perspective. Side load a no. 6 flat with Graphite and make random horizontal floats along the roof to suggest the edges of the slate tiles.

5 Add the cast shadows from the dormer and chimney with Liquid Shadow© and the no. 4 flat. Remove the tape from the roofline. Remove the masking film from the left side of the house and the left side of the dormer. Make sure the masking film remains on the beams and windows. Basecoat the area with Eggshell using a no. 10 flat. Let dry.

Remove the masking film from the chimney and foundation. Mask off the areas around the chimney and foundation with masking film or painters' tape. Basecoat the chimney and foundation with Burnt Sienna. Use only one coat. It doesn't matter if your base is streaky. With a damp natural sponge, apply Driftwood and Dark Chocolate.

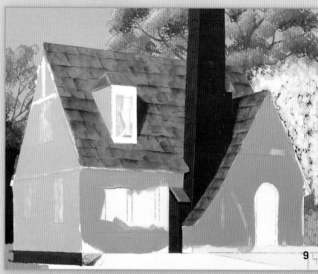

6 While the Driftwood and Dark Chocolate are still wet, sponge on Heritage Brick but allow the other colors to show through. Immediately use a clean, wet sponge to blend the colors. Let dry. Wash Dark Chocolate over the brick area with a no. 10 flat.

7 Use a soapstone pencil or chalk and a straightedge to re-establish the corner and brick lines on the chimney. Use a no. 6 flat and add a wash of Gingerbread to the left side of the chimney and foundation. This wash can look streaky or mottled. Create a variety of washes with different values of Gingerbread, Heritage Brick and Burnt Sienna, and use a no. 2 flat to stroke in bricks following the lines of perspective. Don't try to make actual brick shapes. The stroke alone is enough to suggest the brick.

8 Remove the mask or tape from around the chimney and foundation. Remove the masking film from the copper roofs. Base these areas with Raw Sienna. Use a no. 1 round

to paint the smaller roofs on the chimney. Then use a no. 2 flat and lay very watery Green Mist over the Raw Sienna so the Raw Sienna still shows through. Use a no. 1 round and place Green Mist along the edges of the copper roof to make the edges more defined. Add a bit of Light Buttermilk to the Green Mist and highlight the corner of the dormer roof and the copper on the chimney. Place some Antique Maroon shadows under the roof eaves on the chimney and add this color where the trim will be at the top of the chimney.

9 Remove the masking film from the front of the house and the front of the dormer. Basecoat the front side of the house with Eggshell + Mississippi Mud (2:1) with a no. 6 flat. Don't worry too much about the bottom beneath the front window as this will be covered by foliage. The edges along the roof and wood don't need to be perfect because there will be shadow there. It's OK if your paint has a mottled look, because you are simulating stucco walls.

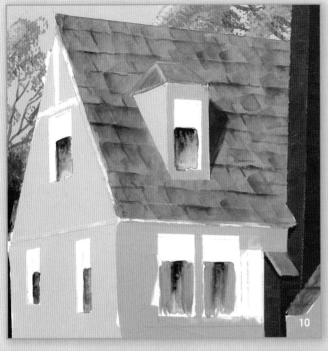

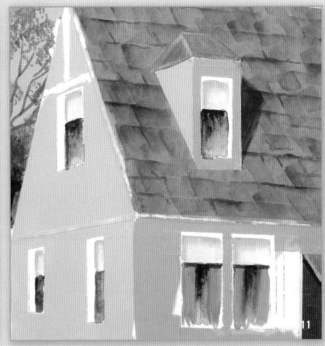

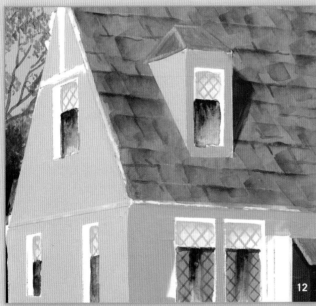

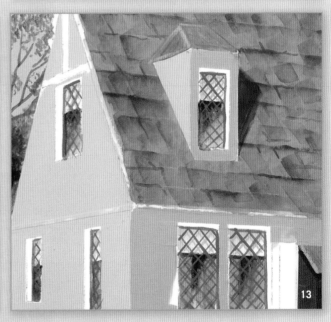

10 Use a pencil to draw in the window shades. Wet the window area beneath the shades and add a wash of Payne's Grey to the water. After the wash sets up, add a little more Payne's Grey to the upper left corners. Mix Payne's Grey + Eggshell to create a light blue and scrub in some curtains on the lower front windows only. The curtains are simply panels on each side of the window. You don't need to take them all the way down the window as the bottom will be covered with flowers.

11 Paint the window shades Bleached Sand with a no. 2 flat. Float Desert Sand at the top of and on the left side of the shades with a no. 6 flat. At the top of the curtains,

run a wash of Prussian Blue to create the shadow made by the curtains.

12 Load a no. 6/0 scroller with Desert Sand and place the shadows of the leaded glass against the window shades. Use Prussian Blue to create the lattice shadow on the curtains.

13 Load a no. 6/0 scroller with Neutral Grey and paint the leaded glass lines on the window just above the shadows on the shades and curtains. Paint the window frame with Neutral Grey.

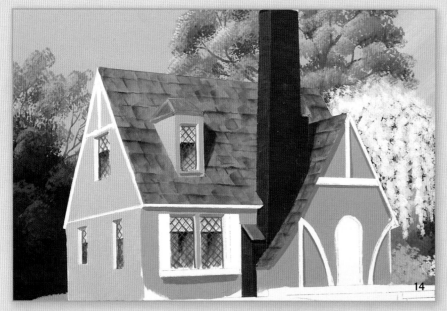

14 Paint the inside window facing with Bleached Sand and the no. 2 round. Mix Eggshell + Mississippi Mud + Prussian Blue (4:1:1) and shade above the windows with a no. 2 round. Also use this mix to shade the front of the house. Use the no. 2 round to place this mixture under the front eaves. Also run the mixture alongside the beams, the front gutter, under the flower boxes, under the roof edge of the dormer and on the front of the house around where the bushes will be painted. Remove the remaining masking film.

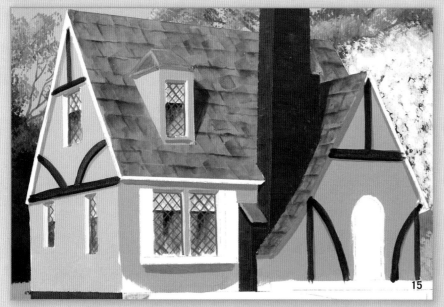

15 Paint the beams with Dark Chocolate using a no. 2 round. One coat should be enough. Streaks in the paint are fine as you are simulating wood. Using the no. 6/0 scroller, run shading on the underside of the beams with Dark Chocolate + a touch of Ebony (Lamp) Black. Also use this dark shadow beneath the eaves where the beam is in the shade.

16 Add the facing on the front of the house with Graphite and a no. 6/0 scroller. Shade beneath the right eaves with Ebony (Lamp) Black + Graphite (1:1). Run this same black color under the eaves on the left side of the house. The facing on the left-side eaves is Slate Grey with a thin line of Graphite for definition.

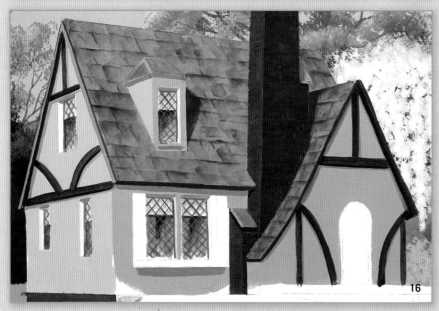

17 Paint the window boxes with Bleached Sand and the no. 2 round. Use ¼-inch (6mm) quilters' tape to tape off the areas around the shutters. Paint the shutters and front door Blue Haze with a no. 2 flat. Use a soapstone pencil or chalk to create guidelines for the braces on the shutters. Mix Blue Haze + Bleached Sand (1:1) and add a highlight to the left side of each shutter with a no. 3/0 round. Also place this highlight around the top of the braces you just established.

Draw in the window on the door and place the highlight on the bottom right of the window.

18 With the no. 3/0 round, mix Blue Haze + Ebony (Lamp) Black (2:1) and shade underneath the brace on the shutters. Also shade the left side and the top of the door. Switch to the no. 6/0 scroller and use the shade mix to paint the cracks in the shutters and the cracks in the door. You only need to paint the top braces on the shutters, because the bottoms will be covered by foliage. Use the same shade color and a C-stroke to create a doorknob.

19 Pencil in the brick trim around the door. Mix Heritage Brick + Dark Chocolate (1:1) and paint the brick trim and the brick porch with a no. 1 round. Highlight the brick with Gingerbread and a no. 1 round.

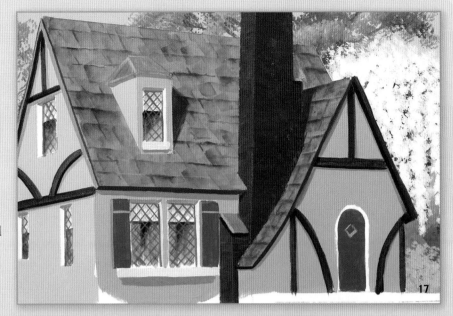

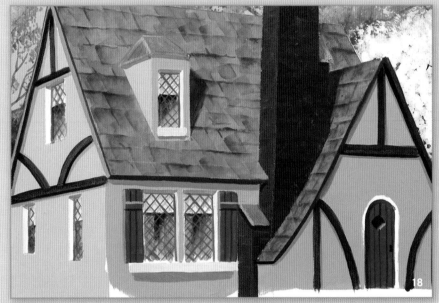

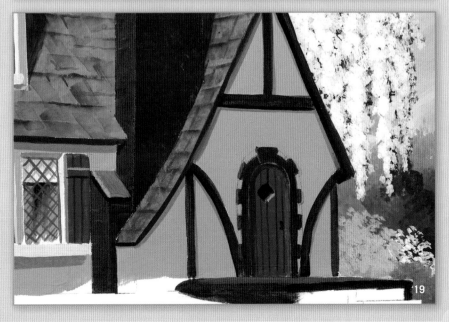

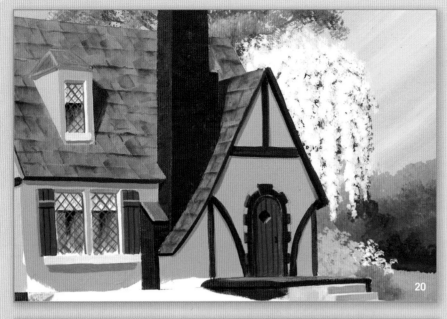

20 Add darker shading to the porch and door trim with Dark Chocolate + a touch of Ebony (Lamp) Black using a no. 6/0 scroller. Basecoat the steps with Eggshell. Shade the steps with Mississippi Mud + Eggshell (1:1). Highlight the steps with Bleached Sand.

21 Use a soapstone pencil or chalk to draw the insignia on the chimney. Or, you can trace it on using white transfer paper. Basecoat the trim at the top of the chimney with Eggshell. Highlight with Bleached Sand. Shade with Mississippi Mud + Eggshell (1:1).

The insignia is painted with Eggshell using the no. 3/0 round. Highlight it with Bleached Sand. Shade with Dark Chocolate + a touch of Ebony (Lamp) Black.

Pencil in the lamp. Put a light wash of Snow (Titanium) White at the bottom of the lamp and fill in the top with Graphite.

22 Use a no. 3/0 round and Ebony (Lamp) Black to add the details to the lamp. Add a touch of Snow (Titanium) White to Graphite to create a light gray and highlight the left side.

Go back and make the shadows deeper where needed, specifically beneath the dormer roof and the cast shadow on the roof that is made by the dormer and chimney.

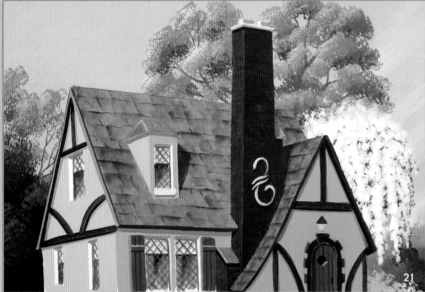

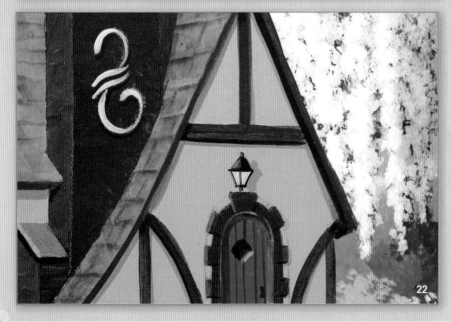

Details

Rhododendron

1 Base the leaves with Evergreen and a no 2 flat. Undercoat the flowers with Snow (Titanium) White.

2 Use a no. 6 flat loaded with Avocado to float along the outer left sides of leaves and right of the center vein. Use the same brush to float Alizarin Crimson around the flowers using a jagged stroke so the float doesn't look too smooth. You want a ruffled effect. Dot centers in with Avocado and a dab of Marigold below or above the center.

3 Float Black Green for the shaded edges of the leaves. Use the no. 6/0 scroller to stroke in the center vein with 1:1 mix of Avocado and Snow (Titanium) White. Add stamens with Avocado and tip with Alizarin Crimson. Add buds after the leaves are done—undercoating with white first.

Vary the values of the greens in the leaves for interest. Basecoat some Evergreen and others Avocado.

Poppies

1 Undercoat the blooms with Snow (Titanium) White. Use a no. 0 round and different values of Evergreen, Avocado and Hauser Light Green to stroke out small leaves. Start darker and go lighter when making the clusters. Use the no. 6/0 scroller to paint the stems. Paint the flowers with a watery Primary Red.

2 Mix Snow (Titanium) White + Primary Red (2:1) to make a pale pink. Use a no. 2 flat to float this around the edges of the flowers.

3 Deepen the centers with Primary Red and a no. 0 round. Add detail to the centers with Black Green + Primary Red (1:1).

Dogwood on Left

1. Paint the branches coming off the left side of the painting as if the trunk of the tree is just beyond that edge but not visible. Use Graphite and the no. 6/0 scroller. Highlight the branches with Slate Grey.

2. Use a no. 1 round to dab on blooms of Eggshell + Avocado (3:1). Makes these blooms look more oblong than round.

3. Dab on more blooms with Bleached Sand. Highlight just a few with Bleached Sand + Snow (Titanium) White (1:1).

Flowers Around House

All the bushes around the house are made using the pouncing method (see page 17) but with different brushes. When you use different shaped scruffies, you can vary the look of the bush. When you put the flower color on the large bushes, use a dry brush. To do this, load your brush as normal, but blot off most paint on a paper towel. Then pounce on your color. This technique will give you a much finer, softer looking shrub. For the bushes, I used Lavender, Alizarin Crimson and Marigold.

The white azaleas below the window and to the right of the steps are pounced bushes as well, but the only difference is in how you apply the flowers. Use a scruffy no. 1 round to dab on the flowers with Bleached Sand.

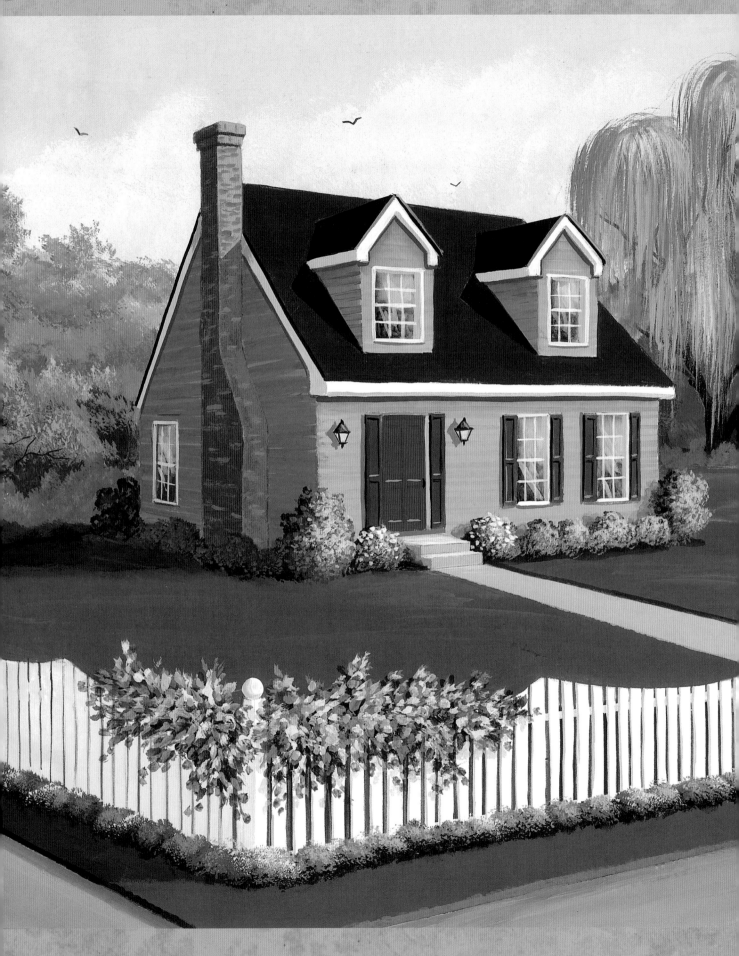

Little Cape Cod

This is a classic

American home, inspired by the first homes built on the coast of Massachusetts. I love the way it is framed by the crisp white picket fence in this old-fashioned summer setting.

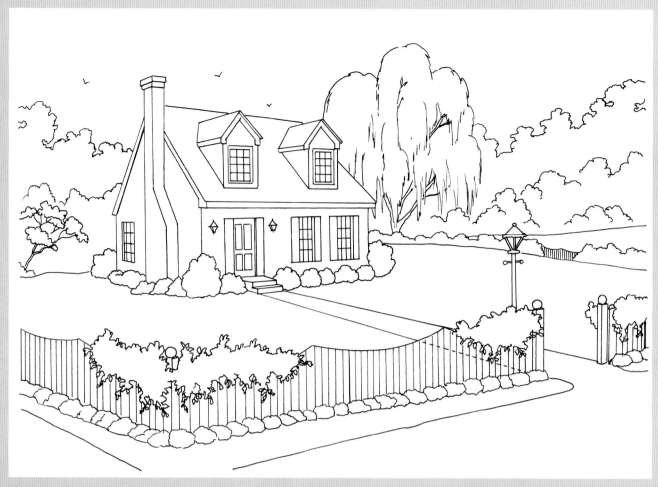

This pattern may be hand traced or photocopied for personal use only. Enlarge at 192% on a photocopier to bring it up to full size.

Materials

DecoArt Americana Acrylics

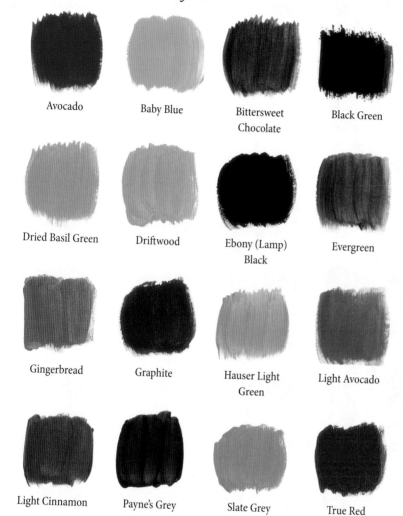

Avocado

Baby Blue

Bittersweet Chocolate

Black Green

Dried Basil Green

Driftwood

Ebony (Lamp) Black

Evergreen

Gingerbread

Graphite

Hauser Light Green

Light Avocado

Light Cinnamon

Payne's Grey

Slate Grey

True Red

Whites

Williamsburg Blue

Snow (Titanium) White

Brushes

Nos. 2, 4, 6 and 10 flats
Nos. 1 and 2 rounds
¾-inch (19mm) wisp
No. 6/0 scroller
⅜-inch (10mm) filbert
 comb
Small, round scruffy

Additional Materials

Masking film
Craft knife
¼-inch (19mm)
 quilters' tape
Soapstone pencil
 or chalk
Liquid Shadow©
T-square
Ruler or straightedge
Natural sponge
Blending gel

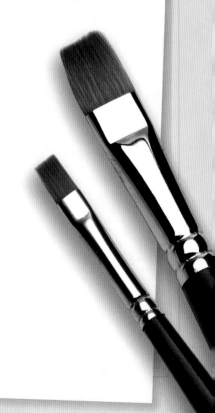

Background

Important: Paint the entire image area with one coat of Snow (Titanium) White before any other painting is started.

Clouds

1 Paint the sky Baby Blue. Mix blending gel and Snow (Titanium) White (1:1). Dab a damp natural sponge into the paint mixture and pounce onto the sky. Take care not to turn or pull the sponge when it is on the surface. The paint should look thin and watery and the cloud formation should be translucent. Pivot your wrist to allow random cloud shapes.

2 Pick up a little more of the paint mixture and continue pouncing on clouds, making each application lower than the first. This will create layers and add depth. Don't overwork your clouds. These need to be light and airy, and the trees will cover a major portion of them anyway.

Weeping Willow

1 Pounce a little bit of very watery Avocado against the sky where the tree foliage will be using a sponge or large flat brush. Let dry. Use a no. 6/0 scroller and Bittersweet Chocolate to paint branches, and fill in the trunk with a no. 1 round.

2 Use a ⅜-inch (10mm) filbert comb loaded with Avocado and loosely outline the tree boughs—first rounding out the upper branches, then stroking straight down.

3 Fill in the branches with Avocado strokes, then add a little Snow (Titanium) White to the green and continue the strokes. Pick up a little Dried Basil Green and add more branches. Make highlighted strokes onto the right sides of the boughs with light blends of Dried Basil Green + Snow (Titanium) White (3:1).

Fence

As a rule, acrylic painting is done from top to bottom, background to foreground. That's because acrylics are generally opaque, and we can overlap colors easily. But that rule doesn't apply when it comes to the fence. If we painted this white fence against the dark green lawn, we'd have a problem of the darker green showing through the white paint. This is why you were instructed to paint your work surface white before you began your painting.

1 Mask off the entire fence with masking film before painting the grass. Paint the background and everything that would be behind and beyond the fence. In this example, I have placed part of the sidewalk so you can see how objects behind the fence—or what you see between the pickets—should be painted.

2 Remove the masking film after the background is complete. On the left side of the gate opening you would see the sidewalk through the spaces in the fence. Draw that in with a light pencil as I have done here. Also draw a line across the fence just below the top of the fence.

With a no. 6/0 scroller stroke Snow (Titanium) White below the pencil line, about ⅛-inch (3mm) wide. This is the frame rail on the back of the fence. There is no need to paint one on the bottom as there will be flowers hiding it. Paint over a couple of times to cover the vertical pattern lines.

Next you will paint the grass and sidewalk between the pickets. Although it sounds tricky, it's just a single stroke of the scroller. Load the scroller with Driftwood and carefully paint over the vertical lines inside the sidewalk guidelines. Be sure not to stroke over the frame rail. Since the grass behind the fence is shaded, make the openings between the fence Avocado + Black Green (1:1). Continue to paint all the vertical spaces in this manner, paying attention to the colors used behind the fence.

3 Use a no. 1 round to paint the shaded sides of end posts with Snow (Titanium) White + Baby Blue (2:1). Use the scroller to paint this onto the left side of each vertical fence picket. Don't worry about getting paint onto the foreground area—it will be covered by flowers later. Erase any visible pattern lines when the paint is completely dry.

Rose Vines

1. Use a small round scruffy, such as a no. 0 or no. 1, and dab on leaf clusters in Evergreen, pointing the leaves so they look like they are growing out from behind the fence post. Layer these with more leaves, only using Light Avocado. Repeat once more with leaves of Hauser Light Green.

2. Mix True Red + Gingerbread (1:1). Dab on roses with the same brush all over the vines, being sure to use random placement for the blooms. Darken this rose color just a tiny bit with Evergreen to make a dark red. Dab on roses near the bottom of the vines.

3. Add a bit of Snow (Titanium) White to the rose color to make a pink, and dab on the lighter roses. Be sure to add shadow on the fence below the vines on the front fence only. (The side fence is already shaded.)

Gaslight

1. With a no. 1 round, paint the gaslight Graphite and highlight the right side with Slate Grey and Graphite (1:1). Use tiny dry brushes of Snow (Titanium) White to add subtle highlight onto the gray.

2. Shade the left side of the lamp with Ebony (Lamp) Black. Paint the glass with thin, milky Snow (Titanium) White.

Bushes Surrounding House

Paint the bushes surrounding the house following the instructions on pages 52-53.

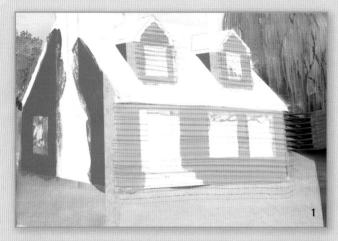

Painting the House

1 Mask off the entire house. Cut out the dormers, windows, roof, trim, chimney and door. Remove the masking film from the front of the house and the front of the dormers. Paint these areas with Baby Blue and the no. 6 flat.

Remove the masking film from the left side of the house and paint it with Williamsburg Blue using the no. 10 flat. Switch to a no. 2 round and paint the left side of the dormers with Williamsburg Blue.

Use ¼-inch (6mm) quilters' tape to mark off the corner edges of the house and dormers.

Load a ¾-inch (19mm) wisp brush with very thin Williamsburg Blue and brush across the front of the house and dormers. Don't worry about stroking over the windows. Make long, straight strokes, keeping with the angle of the house so the lines stay in perspective.

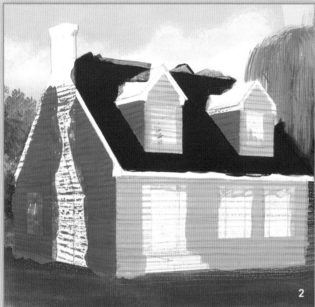

2 Load the wisp brush with very watery Baby Blue and go over the Williamsburg Blue lines from Step 1 to diffuse and blend the lines. This will create the appearance of clapboard siding. Let dry.

Mix Williamsburg Blue + Ebony (Lamp) Black (3:1). Make the mix very watery and load the wisp brush. Paint across the shaded side of the house (the left side) and again, make long, straight strokes while keeping perspective in mind.

Clean the wisp and load it with very watery Williamsburg Blue. Go over the dark lines with this color to diffuse and blend them.

Remove the tape from the corner edges and remove any bleed with a clean, wet brush while the paint is still wet.

Remove the masking film from the roof and basecoat it with two coats of Graphite with a no. 10 flat. Let dry.

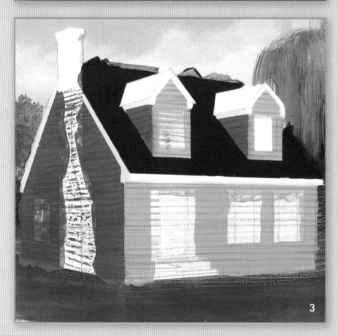

3 Remove the masking film from the dormer roofs and the trim. Paint the trim on the front of the house with Snow (Titanium) White and a no. 1 round. The shaded trim (on the left side of the house) is Snow (Titanium) White + Baby Blue (1:1). The end side of the white trim is also painted with this light blue mix. Use the no. 6/0 scroller to run a line of this shading along the bottom edge of the trim on the front of the house.

4 Paint the dormer roofs with Ebony (Lamp) Black. (I find it easier to outline the areas first with a no. 1 round, then fill in with a no. 2 flat.)

Load the no. 6/0 scroller with Ebony (Lamp) Black and paint in the roof overhang on the right side of each dormer. Run a line of Graphite + Snow (Titanium) White (1:1) on the outside of the roofline you just painted. This creates contrast so you can see the edges of the dormer.

With a no. 1 round, mix Payne's Grey + Williamsburg Blue (3:1) and shade under the shadow-side (left-side) dormer trim. Also run this shadow color under the trim on the left side of the house using a no. 6/0 scroller.

With the no. 1 round, mix Payne's Grey + Williamsburg Blue (1:1) and shade under the front-facing dormer trim. Switch to the no. 6/0 scroller and use this color to shade under the trim on the front of the house. Also shade along the left sides of the shutters (including the shutter left of the door) and under the windows.

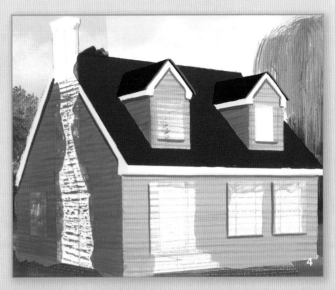

5 Load a no. 4 flat with Ebony (Lamp) Black and paint the cast shadow on the roof caused by the dormers. Load the no. 6/0 scroller with Ebony (Lamp) Black and run a shadow along the rooflines all around the house. Cut the masking film away from the left side of the house.

Remove any masking film left on the windows. Mix Snow (Titanium) White + Payne's Grey (3:1). Load a no. 2 round and paint the top area inside the front window. While that color is wet, pick up some watery Payne's Grey and paint the bottom of the windows. Make the Payne's Grey heavier on the lower left side and then blend the two colors together a bit to soften the edge. With a no. 6 flat float Payne's Grey along the top of the window to add some depth.

Load a no. 2 round with very milky Snow (Titanium) White and make some diagonal reflection streaks in the window.

To paint the far left window on the back side of the house, add a touch of Avocado to Snow (Titanium) White and paint the top corner of the window with this color instead of using the Snow (Titanium) White + Payne's Grey mixture. This light green color represents the trees reflecting off the window glass. Finish the window following the rest of the instructions above.

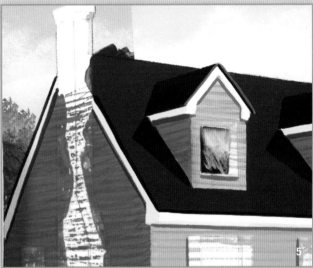

6 Load the no. 2 round with Snow (Titanium) White and run frames around the windows. Because of the angle of the house, the window frame will appear wider on the right side of the windows. The top of the window frame will be a bit wider as well. By the time you finish placing the frames around all of the windows, the paint on the first win-

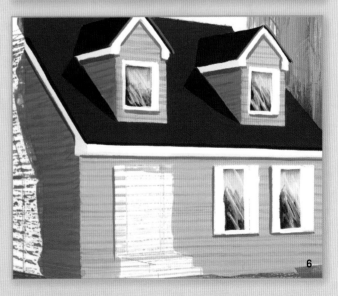

dow frame should be dry and you can place a second coat of Snow (Titanium) White on the trim. On the downstairs windows, the trim on the left sides of the windows will not show because it is shielded by the shutters.

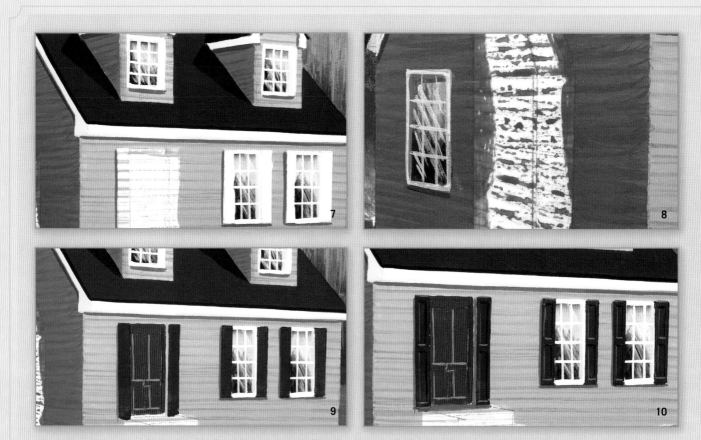

7 Mix Snow (Titanium) White + Baby Blue (1:1). Load a no. 2 round and paint the shaded edges of the window frames on the top and right side of the trim on the dormer windows only. Apply this color to only the right-side trim on the downstairs windows. Load the no. 6/0 scroller with Snow (Titanium) White and paint the window panes. When you paint the panes, it's critical to keep the panes aligned with the lines that create the siding.

8 Paint the trim on the rear left-side window Snow (Titanium) White + Baby Blue (1:1) with the no. 1 round. On the outer side of the window, against the window pane, place a small, thin line of Williamsburg Blue. Add the window panes with the no. 6/0 scroller. Keep in mind the angle of the window panes must be consistent with the angle of the siding.

9 Remove the masking film from the door and the shutters surrounding the door. Mask off the area around the door with ¼-inch (6mm) quilters' tape to create crisp, straight lines. Mix True Red + Gingerbread (1:1) and paint the door using a no. 4 flat. Let dry.

Tape off the edges of the shutters with ¼-inch (6mm) quilters' tape. This may take a bit of time, but the results are worth it. Paint the shutters Graphite with a no. 1 round. Let dry.

Remove the tape. Add a touch of Ebony (Lamp) Black

to the original door color mixture. Load a no. 1 round and shade the top of the door. Load a no. 6/0 scroller and shade the right side of the door.

Use a soapstone pencil or chalk to mark the door panels. Use a ruler or straightedge to ensure straight lines. (Note: A fine line is needed to mark off panels accurately. Soapstone pencils can be sharpened in an ordinary pencil sharpener, or honed to a sharp point on sandpaper.) Load the door shading color on a no. 6/0 scroller and shade the tops and the right sides of the panels.

Add some Snow (Titanium) White to the original door color until you create a light pink. Load this color on a no. 6/0 scroller and highlight the left sides and the bottoms of the door panels. Let dry and then erase any chalk lines. Use Graphite to create a door handle.

10 Use a soapstone pencil or chalk to place the panels on the shutters. Load a no. 6/0 scroller with Ebony (Lamp) Black and shade the tops and right sides of the panels. Mix Graphite + Snow (Titanium) White (1:1) and highlight the left sides and bottoms of the panels with the no. 6/0 scroller. Also run this highlight color on the top of each shutter in a very thin line.

Below the door and shutters, run a line of Williamsburg Blue with the no. 1 round.

Paint the lamps following the instructions on page 66 in the *English Tudor* painting.

11 Remove the masking film from the left side of the chimney but leave it on the areas surrounding the chimney to protect the sky. Tape off the left edge of the chimney to protect the house. The right side of the chimney should still be protected by masking film. Don't worry about masking off the ground as it will be covered by bushes later. Basecoat the chimney's left side with two coats of Light Cinnamon using the no. 6 flat. Let dry.

Remove the masking film from the right side of the chimney. Tape off the edge against the house and the left edge where you painted Light Cinnamon. Basecoat this side of the chimney with two coats of Light Cinnamon + Driftwood (2:1). Where the roof meets the chimney, draw a chalk line to mark where the sun is striking the chimney. Add a bit more Driftwood to the light chimney mix and paint the upper portion of the chimney where the sun is hitting it. Remove the tape and fix any bleeds.

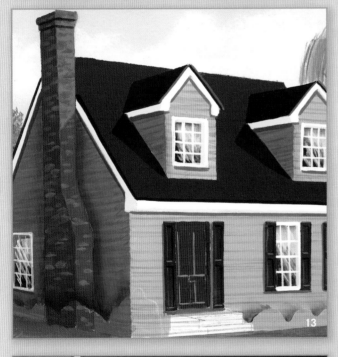

12 Create very thin mixtures of various values of the original chimney colors. Load the chisel edge of a no. 4 flat and add small touches to represent brick on the darker side of the chimney. Keep the angle of the siding in mind as you add the brick; your lines need to match.

Now do the same on the lighter side of the chimney but follow the lines that are on the front of the house as these bricks follow the same directions as those lines.

13 Add shading lines under the top edge of the chimney with a no. 1 round loaded with Bittersweet Chocolate. Loosely chalk in where your bushes will be on the side and front of the house and float Bittersweet Chocolate on the chimney above where the bushes will be with a no. 10 flat. Also use the no. 10 flat to float straight Liquid Shadow© on the house against the right and left sides of the chimney and above the bushes.

14 Basecoat the steps and the sidewalk with Driftwood using a no. 4 flat. Tape off the sidewalk before you paint it. If you have gaps of white spaces around the step, don't worry, this area will be covered by bushes. Use a chalk pencil and T-square to draw in the lines. Keep perspective in mind. The steps follow the same plane as the siding on the front of the house.

Mix Snow (Titanium) White + Driftwood (2:1). Use a no. 1 round to stroke this color on to the top of the top step. Put a few streaks of Snow (Titanium) White against the front edges of the steps. Add a wash of Snow (Titanium) White on the sidewalk. The left side of the step is painted with Driftwood + Graphite (1:1) and the no. 1 round.

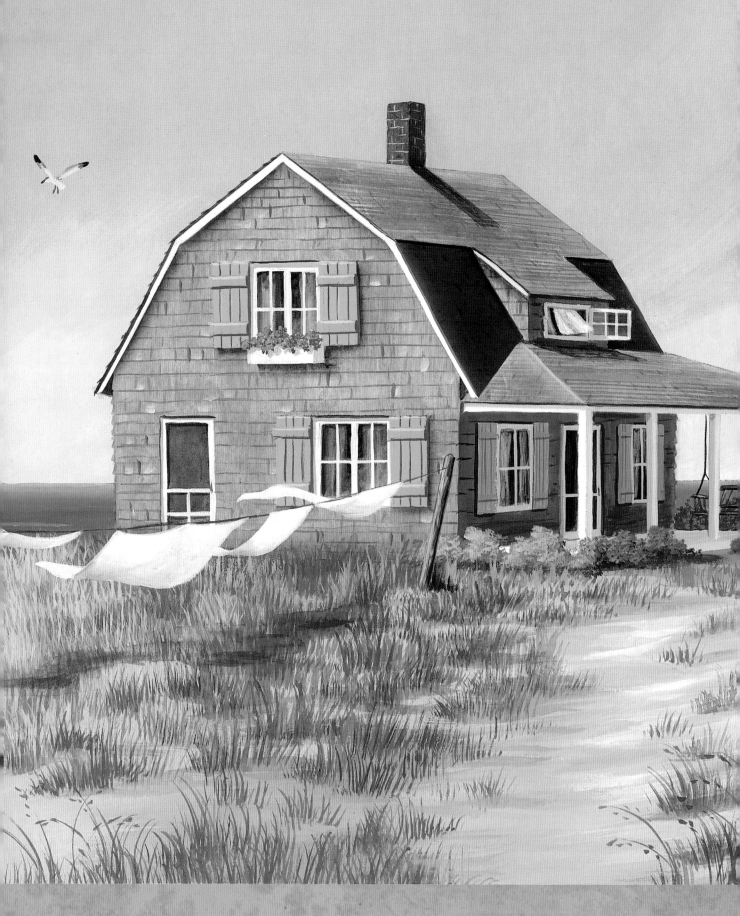

Seaside Getaway

I can just taste the salty air as I imagine walking up the sandy path to this breezy bungalow on the dunes! I've always wanted a summer home overlooking the ocean, and after imagination and brushstokes, I now have one!

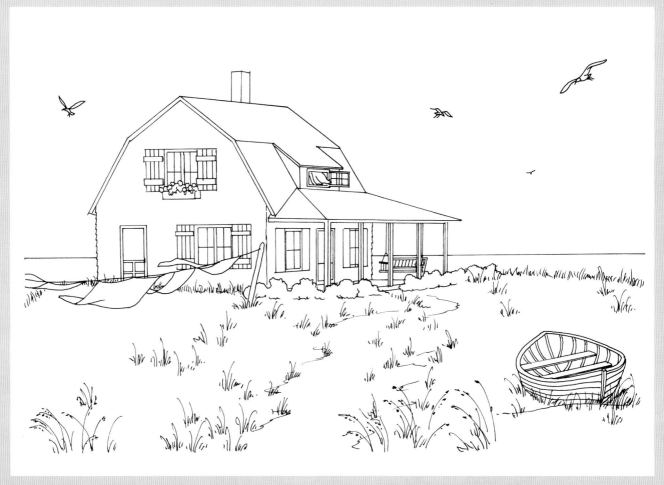

This pattern may be hand traced or photocopied for personal use only. Enlarge at 196% on a photocopier to bring it up to full size.

Sky and Ocean

1. Tape off the horizon. Paint the sky Winter Blue with a large flat, starting at the top and ending at the horizon. Mix Winter Blue and Snow (Titanium) White, and paint this at the tape on the horizon. Immediately, while the sky is still wet, brush the lighter blue up into the sky at a sweeping angle to the right. This will blend the colors and create the wispy cloud effect. Remove tape.

2. When the sky is completely dry, tape it off at the horizon. Make sure you place the tape on the exact same line so the water and sky will meet with no gaps. Mix Blue Haze + Snow (Titanium) White (1:1) and paint the water. Add a little more Snow (Titanium) White to the mix and make the water at the horizon a bit lighter. This will create distance.

Sand

The sand is based with Desert Sand, with a bit of Milk Chocolate toward the bottom. Brush streaks of Bleached Sand for the highlighted spots along the path. Use the chisel edge of a no. 10 flat for this. Use a very watery blend of French Grey Blue and Desert Sand (1:1) for the shadows cast by the grass. Paint the grass on top and just to the left of any shadows you paint (see page 14).

Materials

DecoArt Americana Acrylics

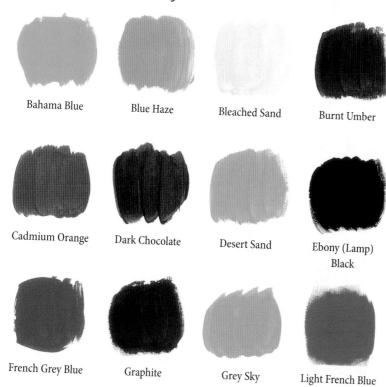

Bahama Blue

Blue Haze

Bleached Sand

Burnt Umber

Cadmium Orange

Dark Chocolate

Desert Sand

Ebony (Lamp) Black

French Grey Blue

Graphite

Grey Sky

Light French Blue

Milk Chocolate

Neutral Grey

Payne's Grey

Slate Grey

Soft Lilac

Winter Blue

Whites

Antique White
Snow (Titanium) White
Warm White

Brushes

No. 4, 6, 8, 10 and 14
 flats
⅜-inch (10mm) and ¾-
 inch (19mm) combs
No. 6/0 scroller
Nos. 20/0, 3/0, 0, 1 and
 2 rounds

Additional Materials

Masking film
Craft knife
Soapstone pencil or
 chalk
T-square
Facial tissue
Natural sponge
Liquid Shadow©
¼-inch (6mm)
 quilters' tape
Pencil
Blending gel

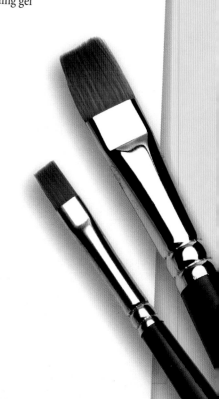

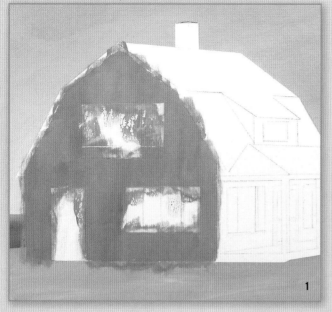

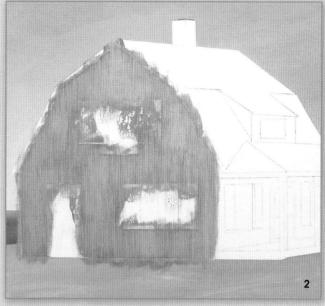

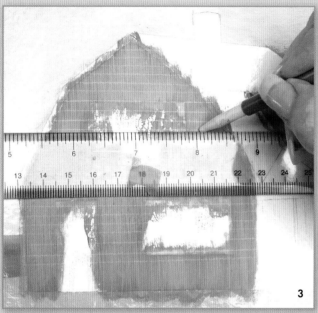

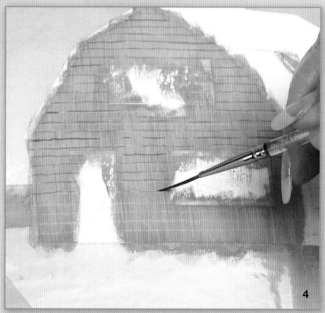

1 Place masking film over the entire house. Cut out the windows, doors, roof, dormer, trim and posts. Remove the masking film from the left side of the house only. With a no. 10 flat, apply vertical strokes of color, alternating between French Grey Blue and Slate Grey. Place the colors next to each other and continue to stroke away so the colors blend together. You will end up with a splotchy blue-gray color that has a distinct vertical grain.

2 Make a watery mix of Slate Grey and load a ⅜-inch (10mm) comb. Apply the wash to the wall in short, choppy, vertical strokes. Add some Snow (Titanium) White strokes to include some variation in color.

3 Remove the masking film from the left side of the dormer and paint it as you did the left side of the house. Let both areas dry.

Use a soapstone pencil or chalk and a T-square to mark off ⅛-inch (3mm) increments. It's OK if the increments aren't spaced exactly even. Start at the top and work your way down, making only horizontal marks. As you mark off the side, be sure to move across the roof and mark off the dormer as well.

4 Make a very watery mix of Graphite and with a no. 6/0 scroller make irregular, intermittent lines across the white chalk marks. You don't want these to be perfect. This is an old, weathered house, and the cedar shingles will have irregular edges on them.

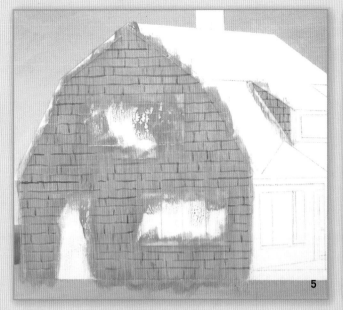

5

6

7

8

5 Still using the no. 6/0 scroller and watery Graphite, make random vertical breaks in the horizontal lines. Use just the tip of your brush for this. These lines need to be staggered, like you would stagger bricks, but they need to be very randomly distributed. You don't need to paint each line. Don't space these lines too far apart or it will look like brick.

Now go back in with a no. 1 round and make some of the vertical lines darker than the others to help prevent uniformity.

6 With a no. 4 flat, float Snow (Titanium) White against the tops of some of the horizontal lines. This will highlight the bottom of the shingles and give the appearance that the shingles are overlapping one another.

7 With a no. 14 flat, float Graphite under the eaves and under the dormer roof. First, float the left eaves. Let it dry and then float the right eaves. The drying time prevents paint lifting at the peak of the roof. As you wait for the float to dry, use a no. 10 flat to float Graphite underneath and to the right of each shutter and underneath and to the right of each flower box. The float on the left eaves should be a tad heavier because the sun is coming from that direction.

8 Remove the masking film from the porch roof and the top section of the roof and dormer. Mask off the siding on the dormer and along the roofline on the front of the house. Make a very watery mix of Neutral Grey and paint the sections with a no. 14 flat. Then blot on some watery Graphite with the same brush. Crumple a facial tissue so it is very wrinkled and lift out some of the color with the tissue.

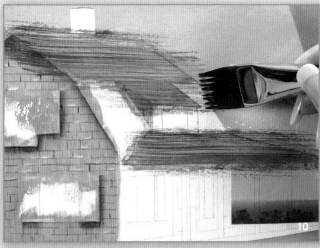

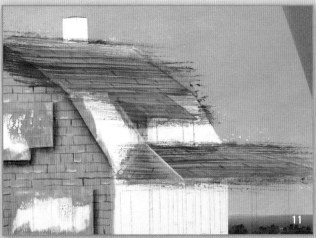

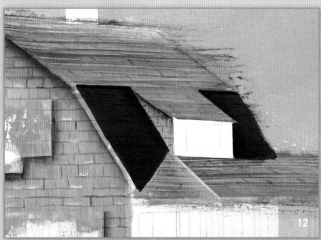

9 Wet a natural sponge and pick up some watery Snow (Titanium) White. Blot the color onto the roof. Load the ¾-inch (19mm) comb with a very watery mix of Graphite and sweep the color over the roof with horizontal strokes. It is very important to follow the angle of the roof with these strokes. The surface is still wet, so the colors will blend a little bit, which is OK. Also take a few streaks of Snow (Titanium) White across the roof. Let dry completely.

10 Load the ¾-inch (19mm) comb with thicker Graphite (but still thin enough to flow off the brush) and sweep the color across the roof. Again, make sure you follow the angle of the roof with your strokes.

11 Load a no. 1 round with the inky Graphite and make vertical lines as you did on the side of the house but make sure to follow the slope of the roof with your strokes. These are very randomly placed strokes. Do the same on the porch roof but make the lines face a different direction on the left side of the porch roof. Find the side roofline on the porch (it follows the front post on the porch all the way up to the dormer) and draw it back in with a soapstone pencil

or chalk. Mix Snow (Titanium) White + Neutral Grey (2:1) and float the color along the porch roofline that you just established using a no. 10 flat. Also float a bit of this color against where the porch roof meets the shaded part of the roof and against the back edge of the porch roof. Float this mix along the very top of the roof.

12 Remove the masking film from the shaded parts of the roof. Basecoat these areas with Graphite using the no. 6 flat. On the right side you may want to switch to a no. 4 flat. This area will require two coats. Let dry.

Mix Ebony (Lamp) Black + Graphite (1:1) and with a no. 1 round make a few random shingle lines, making sure they stay with the angle of the roof. Also make a few random vertical shingle lines.

With the no. 1 round run a line of Ebony (Lamp) Black along the division of the two roof areas (between the top pitch and bottom pitch).

With the no. 10 flat, place a heavy float of Ebony (Lamp) Black along the right side of the dormer window. Make a less intense float on the left side of the dormer on the roof.

Remove the masking film from the dormer window.

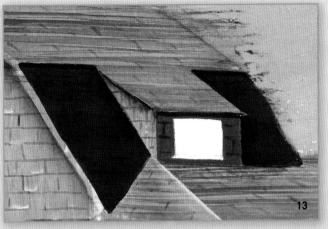

13 Mix Graphite + Grey Sky (2:1) and paint the front face of the dormer with a no. 1 round. With the same brush pick up Graphite with a little bit of Ebony (Lamp) Black and make a few random horizontal and vertical strokes to indicate shingles. Also run this color directly beneath the roof on the front of the dormer.

14 Load a no. 4 flat with Payne's Grey and stroke in the center of the window, leaving a white frame. Let dry.
Paint the white frame with Grey Sky using the no. 1 round.
Use a soapstone pencil or chalk to draw in the open window on the right side of the dormer. Use a no. 1 round and Snow (Titanium) White to paint the outside frame on the open window. Switch to the no. 6/0 scroller to paint the inside window panes

15 Paint the left side of the open window with Grey Sky (paint over the white) to represent shadow. With the no. 2 round, pick up a watery mix of Snow (Titanium) White and paint in some curtains over the Payne's Grey. Then add folds in the fabric with stronger Snow (Titanium) White. With the no. 6/0 scroller, add shadow to the upper window frame with Grey Sky + French Grey Blue (1:1). Add

shadow beneath the dormer window and chimney with pure Liquid Shadow© and the no. 6 flat. At the base of the chimney, where the shadow is the heaviest, stroke in some Ebony (Lamp) Black and blend with the Liquid Shadow© to strengthen the shadow.

16 Remove the masking film from around the house but leave some in place around the chimney and the left side of the roof. Remove the masking film from the trim areas and the front of the house but leave the masking on the windows. It's easy to get bleed under the masking film when you are working with watery paint, so touch up any areas affected by bleed.
The chimney is painted using the same steps found in the *Queen Anne Cottage* (see page 100 for instruction).
Load a no. 2 round with Snow (Titanium) White and paint the trim on the front side of the house. Also paint the trim on the side of the dormer. Load inky Ebony (Lamp) Black on a no. 6/0 scroller and paint the roof edge on the left side of the trim. Also place a very thin line on the right side of the roof and above the trim on the dormer.
With a no. 1 round, create the illusion of shingles on the unseen side of the roof by making some small, angled strokes along the roofline using Ebony (Lamp) Black.

17 Use ¼-inch (6mm) quilters' tape to mask off the area around the front of the house. Paint the front of the house Graphite + Grey Sky (2:1) using the no. 1 round for tight areas. Be careful not to paint over any of the porch posts. Apply two coats for full coverage.

Use a no. 4 flat to paint the inside of the windows and the screen door with Payne's Grey + Graphite (1:1). Leave white space around the window for trim. Around the tight places you may want to switch to a no. 1 round. Add a little Grey Sky to the Payne's Grey + Graphite mix to create a gray mix. With the no. 1 round, stroke in some curtains on the front windows. Just a few strokes on each side of the window will be enough to suggest curtains.

18 Add a few random horizontal and vertical shingle lines on the dark side of the house using Graphite and the no. 6/0 scroller. Also place a line of shading under each shutter on the porch. Remove the tape used to mask off the porch area. Paint the window frames and the trim around the door with Grey Sky and the no. 1 round. Paint the trim dividing the window panes with Grey Sky and the no. 6/0 scroller.

Run a mix of Grey Sky + Graphite (1:1) along the upper edge of the screen door and the two windows and along each outer edge of the screen door.

Paint the shutters on the porch Bahama Blue + Blue Haze (1:1) with the no. 2 round.

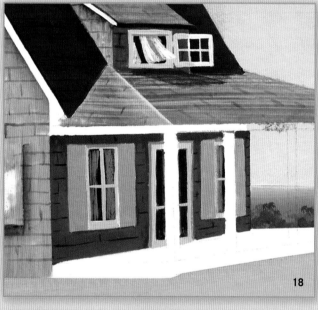

19 Mask off the area around the shutters on the side of the house with ¼-inch (6mm) quilters' tape to create the crisp lines. These shutters are straight Bahama Blue. Use a no. 6 flat to apply the paint. Let dry.

With a pencil and T-square, mark the cross braces on the shutters. Also mark the cracks in the shutters. Load a no. 6/0 scroller with Blue Haze and paint the cracks in the shutters and braces going across them.

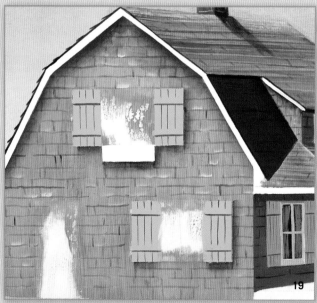

20 Mix Bahama Blue + Snow (Titanium) White (1:1) and highlight the shutters using the no. 6/0 scroller. Highlight each individual slat on the top of the shutter. Do not use one continuous line across the shutter. Use Bahama Blue to highlight the shutters on the porch.

Place ¼-inch (6mm) quilters' tape around the sides and tops of the windows to preserve the window frame. Mix Payne's Grey + Graphite (1:1) and stroke on a thin coat on the windows with a no. 6 flat. It's OK if the paint looks streaky. On the top, dab in some heavier Payne's Grey.

Load the no. 6 flat with watery Snow (Titanium) White and stroke in some illusions of curtains.

21 Remove the tape. Load a no. 6 flat with Payne's Grey and float a shadow directly beneath the edge of the top window frame on the curtain area only.

Use a soapstone pencil or chalk to mark the window panes. To place the panes, measure the very center of the window and draw the line straight down the center, then find the center of each half and draw that line straight down. It helps to have a very sharp soapstone pencil. You can sharpen these pencils in a regular pencil sharpener.

Load a no. 6/0 scroller and paint the trim around the windows Snow (Titanium) White. Use the no. 6/0 scroller to paint down the center of the window a line that is as thick as the window trim. Pressing down harder on the brush will give you a thicker line. Let the Snow (Titanium) White set up and then go over it again to brighten it.

Switch to a no. 1 round and fill in the flower box with Snow (Titanium) White. The right side of the box is Grey Sky.

Shade at the top of each window frame with Grey Sky using the no. 6/0 scroller. Place the shading at the top and at the left side of the window frame against the shutter. This shading helps recess the window.

Paint the door on the sunny side of the house following the instructions for the windows on that side.

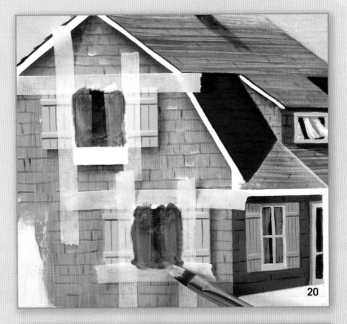

20

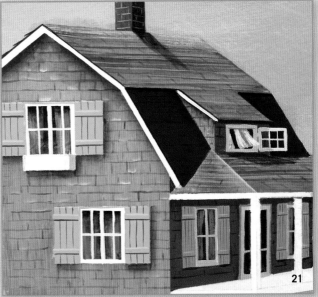

21

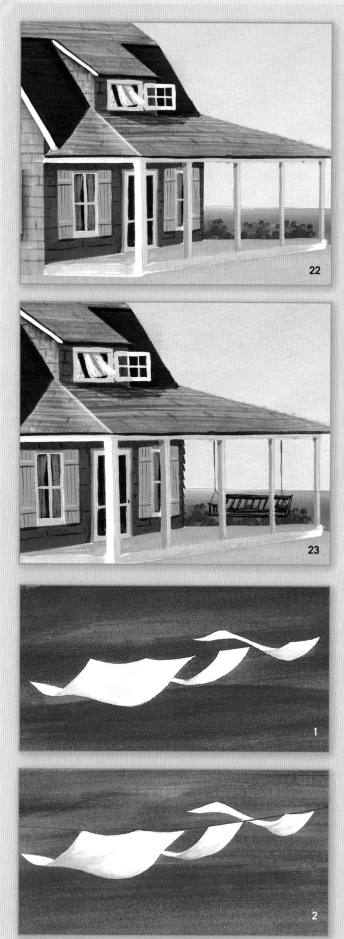

22 The trim on the shaded part of the house is painted Grey Sky with the no. 6/0 scroller. Mix Grey Sky + a touch Graphite and paint the floor of the porch. Paint the lower edge of the porch with this mixture. Don't worry if it's streaky as most of it will be covered by shrubbery. Paint the right sides of all of the posts with Grey Sky. Load the no. 6/0 scroller with Grey Sky + French Grey Blue (2:1) and paint the left side of each porch post except for the corner post (the one closest to the viewer).

Add a touch of Snow (Titanium) White to Grey Sky and streak the color down the front post where you previously painted the Grey Sky. This gives the post a rough, weathered appearance. At the very top of each post you will have a small triangle of shadow where the post meets the trim. Use French Grey Blue to paint this shadow using a no. 20/0 round. Load the no. 6/0 scroller with Graphite + Ebony (Lamp) Black (1:1) and run the color along the edge of the roof above the porch.

23 Use a no. 20/0 round and Graphite + Grey Sky (1:1) to add individual shingle marks to the corner next to the porch swing, just as you did the unseen side of the roof in Step 16. Paint the frame of the porch swing with a no. 1 liner and Burnt Umber. Switch to the no. 6/0 scroller and paint the vertical slats. Add a little Snow (Titanium) White to the Burnt Umber and highlight the swing. On the side edges, place a few fine lines of Ebony (Lamp) Black to show some shadow. Paint the chain with Ebony (Lamp) Black using the very tip of the no. 6/0 scroller.

Details

The sheets and boat are among the last elements to paint. Mask off the sheets with masking film before painting the house or grass. Burnish the film well. Begin painting sheets only after all the grass and house is complete. When they are, remove the masking film from sheets.

Sheets

1 Paint the sheets Snow (Titanium) White. Mix Snow (Titanium) White + Soft Lilac + Light French Blue (3:1:1). Use a no. 2 round and paint very watery shading on the undersides of the sheets with this mixture. Blend into the pure white. Use blending gel if desired. The coverage does not have to be even. Let dry.

2 Mix the above colors again, this time with one part less white, and add more intense shadow. Allow a few streaks to show as ripples in the sheets. Keep the shading to a minimum—these are white sheets! Paint the clothesline Dark Chocolate with the tip of the no. 6/0 scroller.

1
2
3
4

Old Boat

1 Base the inside of the boat with a no. 4 flat and Slate Grey. Base the left outer area with Slate Grey + Snow (Titanium) White (1:1). Base the right side with a no. 2 flat and Graphite. Draw in the keel with a chalk pencil. Use a scruffy no. 4 flat to drybrush shades of Graphite and Snow (Titanium) White on the inside of boat. Start at the keel and stroke outward, following the contour of the sides. (It helps to use masking film to protect the background and outside of boat.)

2 Use white graphite paper and transfer the ribs and seats. Use a no. 1 round to paint right-side ribs with a mix of Snow (Titanium) White + Slate Grey (3:1). Make them a bit darker on the left side. Shade each rib with Graphite. Paint the tops of the seats with the same light gray mix, and shade edges with Graphite and no. 6/0 scroller. Drybrush Snow (Titanium) White onto the left side of boat (outside) with a no. 4 scruffy, following the shape of the boat. Do the same on the shaded side of the boat with a drybrush of Slate Grey.

3 Use a no. 6/0 scroller and watery Graphite to paint the clapboard sides. Use a thicker Graphite on the shaded side. Paint the edge of the boat the same color as the seats using a no. 1 round. Paint the left side of the keel with this color, and shade with Graphite.

4 Add detail shadows first by running Graphite below the outer edge of the boat with the scroller. Use a no. 1 round and add Graphite shadow under the seats. Brush a thin wash of Graphite into the left inside bow. Use a no. 10 flat to float Graphite shadow on the seat, along the bottom of the outside of the boat and across the bottom of the keel. Float Ebony (Lamp) Black with a no. 8 flat on edges of the shaded side of the boat. Then float Ebony (Lamp) Black against the edge of boat on the inside left. Drybrush Snow (Titanium) White onto lightest areas of the boat. Use a no. 0 round to add a jagged crack with Ebony (Lamp) Black.

To make the boat appear sunken into the sand, bring the sand color up onto the bottom of the boat about ⅛ inch (3mm). Be sure to make a shadow in the grass and sand very dark. Remember, it's the proper placement of light and shadow that gives objects depth and dimension.

Seagulls

1. Paint the birds Snow (Titanium) White with a no. 3/0 round. Paint the underneath side of the wings Slate Grey.

2. Paint the wing tips Ebony (Lamp) Black and blend just slightly into the white (or gray if on the underneath) with a clean, wet brush.

3. Paint the head Ebony (Lamp) Black and highlight the head with Graphite (on largest bird only). Paint the legs Graphite.

4. Paint the beaks with Cadmium Orange.

Queen Anne Cottage

I love to paint Victorian cottages. The more it looks like a dollhouse, the more fun I have! In this project I kept the trim to a minimum, but feel free to embellish upon my design by adding your own fancy gingerbread trims.

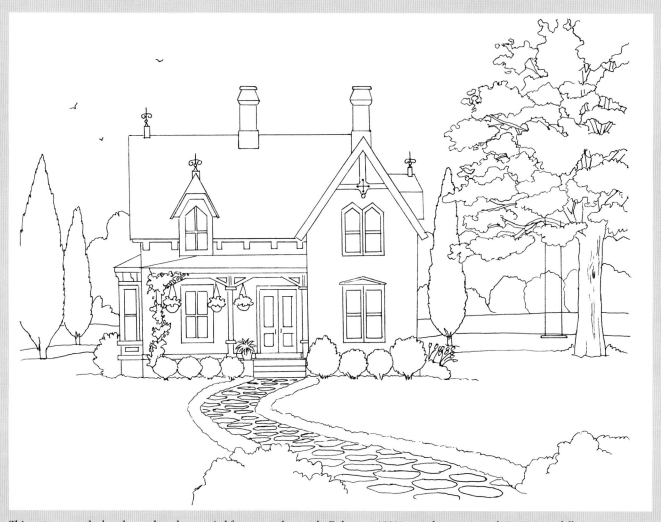

This pattern may be hand traced or photocopied for personal use only. Enlarge at 179% on a photocopier to bring it up to full size.

Sky, Background Foliage and Grass

Paint the sky with Baby Blue. Pounce on the background foliage using blends of Hauser Medium Green, Hauser Dark Green and Snow (Titanium) White. The distant grass is Hauser Light Green + Snow (Titanium) White (2:1). The foreground grass is blends of Hauser Dark Green, Hauser Medium Green and Snow (Titanium) White. See page 19 for detailed instructions on painting grass.

Materials

DecoArt Americana Acrylics

Admiral Blue

Avocado

Baby Blue

Bleached Sand

Burnt Umber

Camel

Dark Chocolate

Driftwood

French Vanilla

Grey Sky

Hauser Dark
Green

Hauser Light
Green

Hauser Medium
Green

Heritage Brick

Lavender

Midnite Green

Milk Chocolate

Mississippi Mud

Payne's Grey

Raw Umber

Sable Brown

Slate Grey

Whites

Snow (Titanium) White

Brushes

Nos. 2, 4, 6, 10 and
14 flats
Nos. 3/0, 0, 1 and 2
rounds
No. 6/0 scroller
Mop brush
Scruffy angular shader

Additional
Materials

Masking film
Craft knife
T-square
Pencil
Soapstone pencil or
chalk
Art gum eraser
Painters' tape
¼-inch (6mm)
quilters' tape
Liquid Shadow©

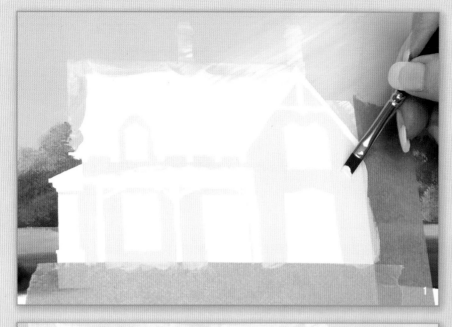

1 Place masking film over the entire house and cut out the windows, doors, trim and roof. Use a smooth, low-tack painters' tape to tape off the right edge and the foundation of the house to protect the background painting.

Remove the masking film from only the siding of the house. Block in the house with French Vanilla using a no. 4 flat around the detail areas. Switch to a no. 6 flat for larger areas. For very small areas use a no. 3/0 round. You may need to use two coats of French Vanilla for full coverage. It's OK if the paint looks a little streaky because it will likely be covered later with shading.

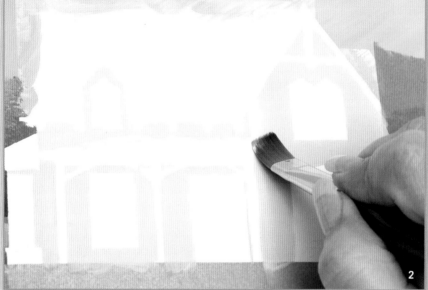

2 With a no. 14 flat, float Snow (Titanium) White along the outside of the house as a highlight.

3 On this house, the shadows are going to be to the left of and underneath objects. Place a shadow directly under the eaves with Camel. Use a no. 2 round to make the shadow about ⅛ inch (3mm) thick. Also place shadows underneath and on the left side of the windows.

4 Float a lighter shadow on the right sides and the tops of the windows with a no. 10 flat loaded with Camel.

5 Use a pencil and a T-square to draw in where the shadow needs to fall on the area beneath the overhang for the porch. Use a very light touch with your pencil. Fill in this shaded area with Camel using the no. 2 round. Don't worry if you get paint on the porch's white trim. You can adjust that area later.

Mix Camel + Milk Chocolate (1:1) and intensify the areas where your Camel shadows were lost (the eaves in the shadow above the porch and around the window on the far left side of the house).

6 Paint the trim Snow (Titanium) White with a no. 2 round. Wet the inside of the windows with water then drop some Baby Blue into the water. Avoid the window frame.

7 Rewet the bottom of the window and add Avocado + a touch of Payne's Grey. This represents the glass reflecting the sky and trees.

8 Still using the no. 2 round, use Snow (Titanium) White thinned with water to add the suggestion of curtains. Do not add detail to the curtains. With a very thin wash of Payne's Grey, add a shadow under the window frame on the glass. Shade the white window trim with Grey Sky using a no. 6/0 scroller.

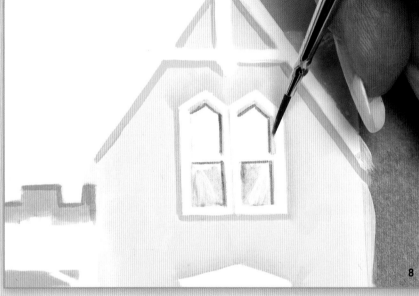

9 Paint the white trim to the right of the door with Grey Sky to create the cast shadow caused by the front of the house. With Grey Sky and the no. 6/0 scroller, add three lines of shadow to the white trim under the roof of the porch.

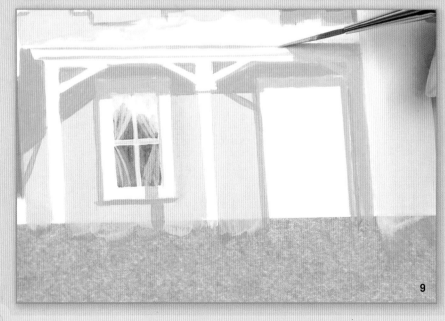

10 On the shaded trim to the right of the door, intensify the shadows and create the details with Slate Grey and the no. 6/0 scroller. Let dry.

11 Place painters' tape or masking film around the door to ensure crisp, straight lines. Basecoat the door with Hauser Medium Green and a no. 6 flat. Add shadow along the top and right side of the door with Hauser Medium Green + Hauser Dark Green (1:1) and the no. 6 flat. Let dry.

Use a soapstone pencil or chalk and a T-square to mark off the panels on the door. Mix Hauser Medium Green + Snow (Titanium) White (1:1) and paint the highlighted edges of the panel on the lightest side of the door using a no. 3/0 round. Shade the other side of the panel with Hauser Medium Green + Hauser Dark Green (1:1).

For the right panel use Hauser Medium Green for the highlight edge (the left edge of the panel) and use Hauser Dark Green for the darkest edges (the top and right edges of the panel). Paint the crack between the two doors with Hauser Dark Green. Let dry. Remove chalk lines with an art gum eraser.

12 Remove the masking film from the roof. Mask around the roof and porch roof to protect areas painted in earlier steps. (To mask very thin areas, I like to use ¼-inch (6mm) quilters' tape. For larger areas, use painters' tape.) Mask the dormer window with masking film.

Basecoat the roof with Milk Chocolate and the no. 14 flat. You may need to apply two coats. For even coverage, apply the paint in one direction for the first coat, and for the second coat, apply the paint in the direction perpendicular to the first coat. Let dry.

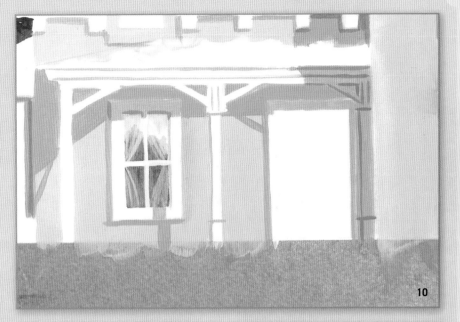

10

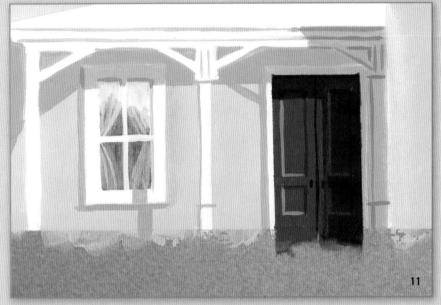

11

12

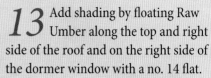

13 Add shading by floating Raw Umber along the top and right side of the roof and on the right side of the dormer window with a no. 14 flat.

14 To create the gable and dormer cast shadows on the roof, mix Liquid Shadow© + Raw Umber (1:1) and apply very thinly with a no. 10 flat.

15 Immediately mop out the edge of the cast shadows with a dry mop brush. Let dry.

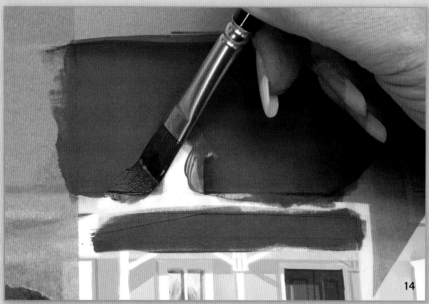

16 Use a T-square to mark off ¼-inch (6mm) increments on the left side of the roof. Use the soapstone pencil or chalk to lightly draw in the lines of the roof. Make the lines a little closer together for the porch roof and the gable on the right of the house.

Use the tip of a no. 6/0 scroller with a very watery wash of Raw Umber to paint the lines. Continue right over the masking film on the dormer so your flow is not interrupted. Let dry and remove tape. If a tiny hairline appears between the roof and the sky when you remove the tape, fill in the area with Baby Blue or Milk Chocolate. If you have any seepage beneath the tape, paint over it with the appropriate color.

17 Base the dormer roof with a mix of Milk Chocolate + Snow (Titanium) White (4:1). Add a touch more Snow (Titanium) White to the mix and paint the edge along the dormer roof as a highlight and to separate it from the roof behind it.

The base of the finial is Driftwood painted with a no. 1 round. Add a little Snow (Titanium) White to the Driftwood for accent and highlight on the right and upper edges. Draw in the finial with soapstone and paint it with Raw Umber using the no. 3/0 round.

18 Add a touch of Driftwood to Raw Umber and highlight the finial with a no. 3/0 round.

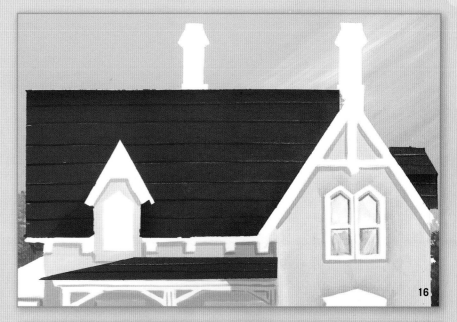

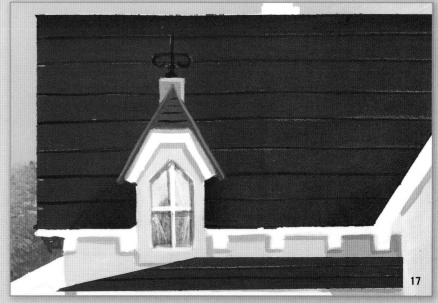

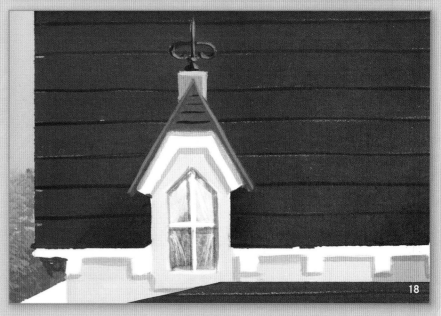

Details

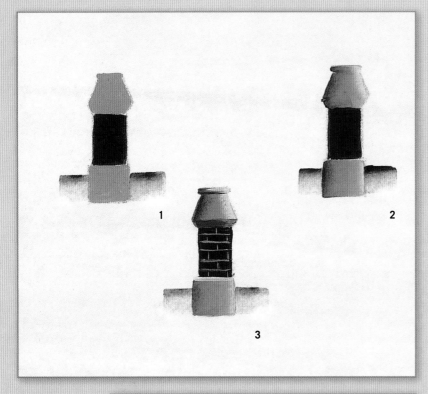

Chimneys

1 Base the cement parts with Driftwood and the bricks with Heritage Brick with a no. 2 flat.

2 Float Mississippi Mud on left side of the cement parts with a no. 6 flat. Float Bleached Sand on right side.

3 Add detail shadow with Raw Umber and a no. 0 round. Add a brighter highlight of Bleached Sand around the rim and upper edge of the base. Use a no. 6/0 scroller to add mortar between the bricks with Driftwood.

Steps

1 Base the steps with Snow (Titanium) White. Use a no. 6/0 scroller to make step lines in Driftwood. These simulate the shadow from the overhang of the stair tread.

2 Use Grey Sky and a no. 2 flat to add shadow on the steps.

3 Deepen the stair tread shadow with Driftwood darkened with just a touch of Graphite.

Large Tree

See page 28 for instructions on painting the large tree with the swing. Use various shades of green for the foliage.

1 2 3

Cedar Trees

1 Use a scruffy angular shader to pounce in tree branches with Avocado. Keep branches angled upward. Use a no. 1 round to paint the trunk Raw Umber.

2 Pounce Midnite Green branches onto the left side of the tree with the same scruffy brush.

3 Pounce highlight onto the right of the tree with Hauser Light Green. Add a touch of Snow (Titanium) White to Raw Umber and add highlight to the trunk with the no. 1 round.

Swing

1. Use the no. 6/0 scroller to paint the ropes Milk Chocolate, making sure your lines are straight and vertical.

2. Paint the seat Raw Umber with a no. 3/0 round.

Foreground Bushes

1. Use a large scruffy or Scheewe Foliage brush to pounce on bushes with Midnite Green and Hauser Light Green.

2. Dab on two- and three-petaled flowers in Lavender using a no. 1 round. Mix a bit of Snow (Titanium) White into the Lavender to lighten it (1:1) and dab highlight petals onto the flowers.

Plant by Door

See page 41 and follow the directions on how to paint the fern and stand.

See page 27 for basic directions for painting hanging baskets.

Morning Glory Vine

1. Use a no. 3/0 round to dab on leaves in different blends of Midnite Green, Avocado and Hauser Light Green.

2. Dab on dots of flowers with different shades of Admiral Blue and Baby Blue.

Stone Walk

1. Basecoat the sidewalk with Driftwood.

2. Put a small amount each of Dark Chocolate, Burnt Umber and Sable Brown on your palette. Make watery mixes of each color. Use a no. 1 round, and starting up at the steps, stroke in narrow stones, keeping your stroke translucent. Alternate the colors, and stagger the stones. Make the stones larger and wider as you get closer to the foreground.

3. On the largest stones in the foreground make an edge on the left side of each one with a stronger mix of the color you used on the stone.

4. When the sidewalk is dry, use a no. 14 flat to float a shadow on the right using Burnt Umber. Start the shadow at the curve of the walk. Any shadow cast by the border plants wouldn't be visible beyond that.

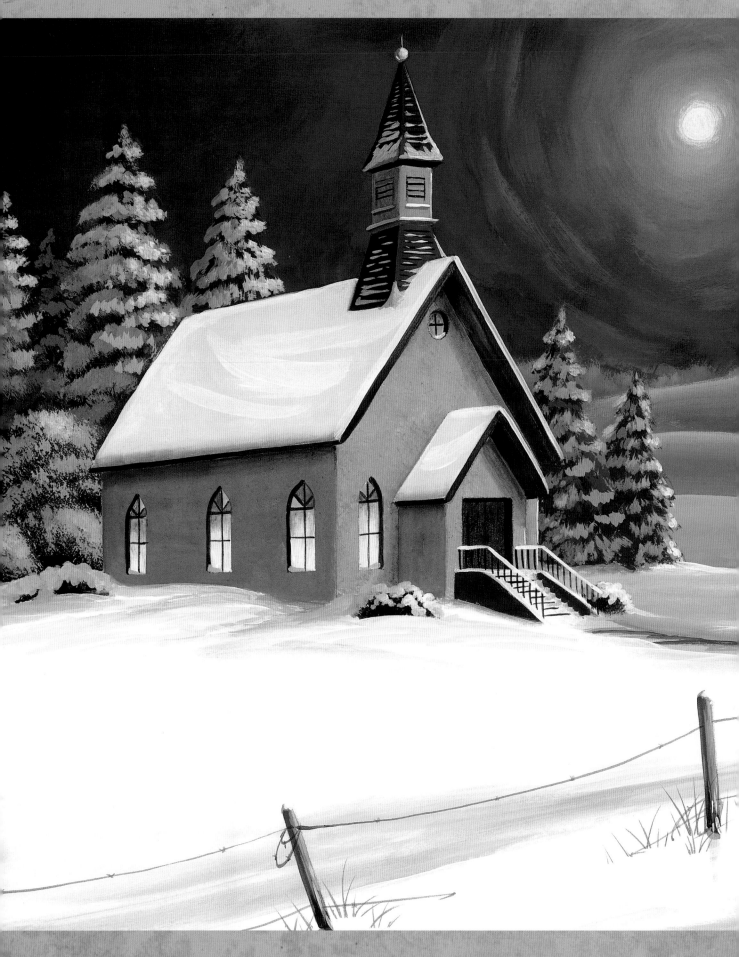

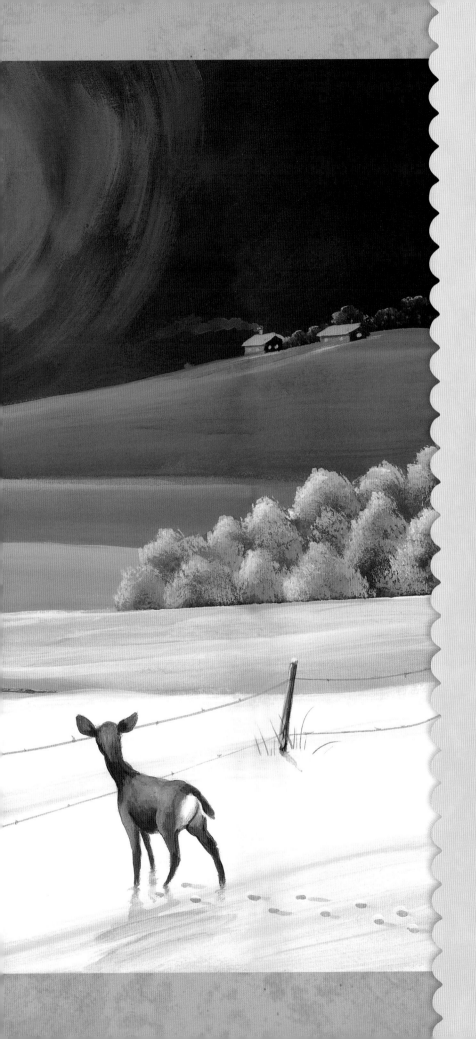

Chapel in Winter

The amber glow from the windows of this little chapel seems to warm the snowy surroundings, and the wintry moon illuminates everything it shines on.

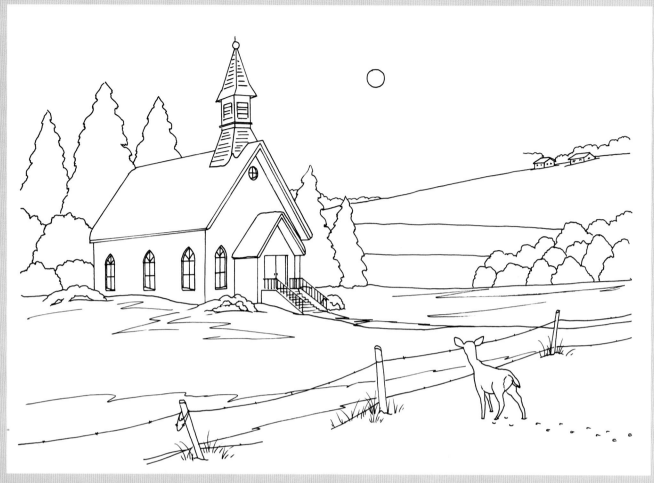

This pattern may be hand traced or photocopied for personal use only. Enlarge at 196% on a photocopier to bring it up to full size.

Materials

DecoArt Americana Acrylics

 Admiral Blue

 Bittersweet Chocolate

 Black Green

 Burnt Sienna

 Burnt Umber

 Camel

 Deep Periwinkle

 Desert Sand

 Ebony (Lamp) Black

 Festive Green

 Graphite

 Hauser Dark Green

 Honey Brown

 Lavender

 Milk Chocolate

 Mink Tan

 Payne's Grey

 Primary Yellow

 Prussian Blue

 Sapphire

 Soft Lilac

 True Red

 Williamsburg Blue

Whites

 Snow (Titanium) White

Brushes

Nos. 2, 4, 6 and 10 flats
Nos. 3/0, 0, 1 and 2
 rounds
No. 6/0 scroller
⅜-inch (10mm) comb
Small, round scruffy
Scruffy angular or flat

Additional Materials

Masking film
Craft knife
Painters' tape
Natural sponge
T-square
Pencil
¼-inch (6mm)
 quilters' tape
Soapstone pencil
 or chalk
Blending gel

Background

A good shortcut for this project is to paint your entire surface with Snow (Titanium) White before transferring pattern.

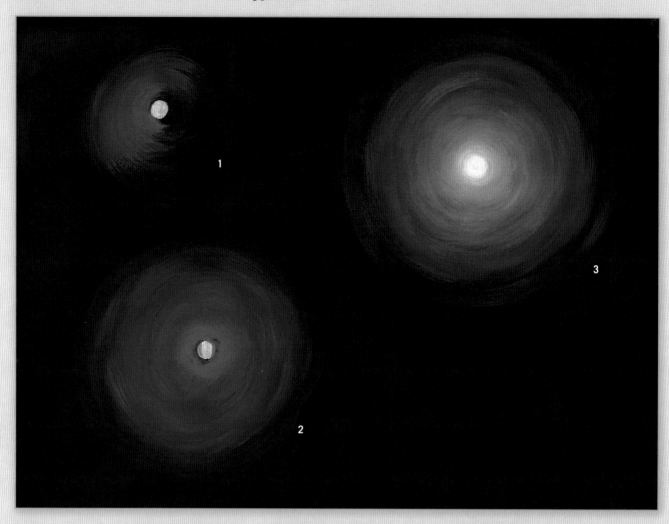

Moon

Paint the sky Payne's Grey, mixing Admiral Blue and Williamsburg Blue into it on the surface, and mopping the colors together to blend. Use a no. 10 flat or other large brush for this. Keep a deeper concentration of Payne's Grey near the edges and upper corners.

1 Paint the moon with one coat of Snow (Titanium) White. Paint the surrounding area with blending gel using a ⅜-inch (10mm) comb. Pick up random blends of Williamsburg Blue and Payne's Grey and begin stroking in a circular motion around the moon. Turn your surface as you work to make this easier.

2 Make the paint thinner (use more blending gel) as you work outward. When you have made a "halo" of light blue about 4 inches (10cm) around, change to Payne's Grey and blending gel and blend the colors into the background. Don't worry if you get paint on the moon at this time. It's there only as a guide for now. Let dry completely.

3 Use a no. 2 flat to repaint the moon Snow (Titanium) White. Switch to a no. 6 flat and paint blending gel around the moon. Stroke thin Snow (Titanium) White around the moon and carry it out into the circle, allowing the blending gel to dilute the white to a filmy haze. Continue to turn your surface to keep the coverage consistent. Don't strive for a perfectly smooth blend. Having a "choppy" halo around the moon will help suggest frosty night air!

Distant Houses

1 Paint the distant trees Black Green with a no. 1 round. Float Williamsburg Blue along tops with a no. 2 flat. Use a no. 3/0 round to paint the left sides of the houses with Soft Lilac + Williamsburg Blue (1:1). Paint the right sides Prussian Blue. Paint roofs the same color as the hills: Soft Lilac + Williamsburg Blue + Snow (Titanium) White (1:1:1).

2 Undercoat the windows with Snow (Titanium) White— just little specks made with a no. 3/0 round is all you need. Use the no. 2 flat to drybrush Snow (Titanium) White under the windows. This undercoating of white is necessary for the yellow in the next step to show up well. Use the same brush to run a line of very thin Payne's Grey under the roof overhangs.

3 Paint Primary Yellow over the undercoated windows and on the snow. Use the same no. 3/0 round with just a touch of watery Snow (Titanium) White and paint smoke from the chimney.

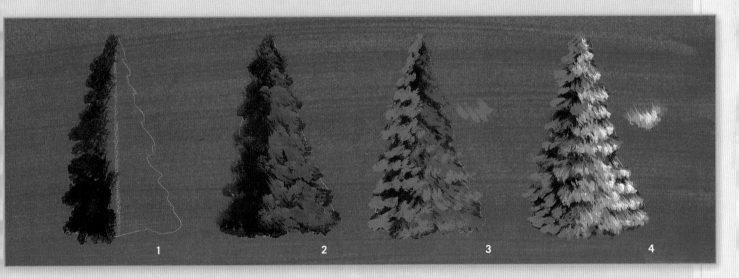

Snow-Covered Evergreens

1 Mix Hauser Dark Green + Payne's Grey (1:1). Use chalk to draw a center guide line within the tree. Use a scruffy angled or flat (no. 6–8) and pounce on foliage with the tip of the brush pointing downward at an angle. Pounce in the outer branches. Branches to the left of the guide line will angle off to the left. Ones to the right will angle out to the right. Ones down the center will be vertical.

2 Add just a touch of Snow (Titanium) White to the green mixture and pounce in lighter branches on the right side.

3 For the deeply shaded snow, use a scruffy round brush and stroke on Deep Periwinkle starting at the bottom and working up. Point the brush downward and stroke up as shown in the sample. Don't cover the whole tree, but allow green branches to show through the snow.

4 Mix Deep Periwinkle + Soft Lilac (1:1). Use the same strokes as before with the same brush, painting only on the right of the tree on top of the darker strokes already in place. Lastly, stroke Snow (Titanium) White for the brightest snow but only on top of the previous light lavender mixture.

Painting the Chapel

Mask off the roof and steeple with painters' tape. Protect the windows, the roof over the entryway, the stairs and right along the snow line in front of the church with masking film.

1. Basecoat the church and steeple with Desert Sand using the no. 6 flat. Paint right over areas covered with masking film. Let dry.

2. Load a damp natural sponge with Mink Tan and pounce the color over the basecoat.

3. Load the natural sponge with Mink Tan + Desert Sand (1:1) and pounce over the basecoat a second time. While the paint is still wet, rinse the sponge and blot it over the chapel to soften and diffuse the paint.

4. Use a T-square and pencil to reestablish the lines that mark the corner of the church and the entryway. Make a wash with Mink Tan + Payne's Gray + Burnt Umber + water (3:1:1:6) and wash it over the darker sides of the chapel, steeple and entryway with the no. 10 flat. Also stroke this wash under the eaves. Remove the tape and masking film from the roof areas.

5 Basecoat the shaded side of the steeple (the left side) with Ebony (Lamp) Black and no. 4 flat. Paint the right side of the steeple with Graphite. Paint the ornament on top of the steeple with Camel. Add a small Snow (Titanium) White highlight to the right side of the ornament. Add a touch of shading to the left side with Milk Chocolate. Paint the spire Ebony (Lamp) Black with a Snow (Titanium) White highlight on the right side. Add Ebony (Lamp) Black under the eaves of the steeple with a no. 1 round.

6 On the steeple and its roof, suggest louvers with Ebony (Lamp) Black and a no. 1 round. For the snow on the shaded side of the steeple, mix Soft Lilac + Deep Periwinkle (1:1) and apply with a no. 1 round. Also run this paint across the ledges and louvers farther down the steeple and in the corner at the very bottom of the steeple.

7 Use the no. 1 round to apply Snow (Titanium) White along the louvers on the right side of the steeple. To shade the snow on the eaves, use a color that is one shade darker than the snow. On the left side use Deep Periwinkle. On the right side use Soft Lilac. This creates depth in the snow.

8 Tape off the front eaves with ¼-inch (6mm) quilters' tape. Paint the right eaves Graphite with a no. 6 flat. With a no. 10 flat, float some Ebony (Lamp) Black into the peak of the eaves. Also paint the right eaves of the entryway with Graphite and use a no. 6 flat to float Ebony (Lamp) Black into the peak of its eaves. Paint the trim along the eaves of the chapel and the entryway with Burnt Umber and a no. 1 round.

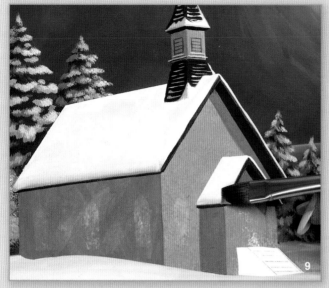

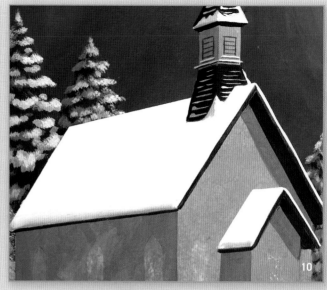

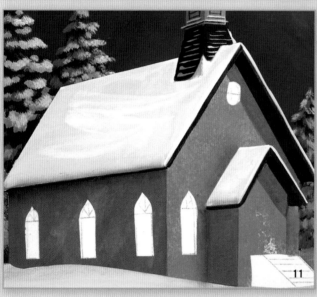

9 Load the no. 6/0 scroller with Snow (Titanium) White and apply a thin line of snow along both sides (front edges) of the roof. Dab over any transfer marks with Snow (Titanium) White. Paint the eaves on the left side of the chapel and entryway with Burnt Umber + Ebony (Lamp) Black (2:1) and the no. 6/0 scroller.

Change your water so you have clean water to paint the snow on the roof. Basecoat the roof with Snow (Titanium) White + Soft Lilac (2:1). Use a no. 10 flat for the chapel roof and a no. 6 flat for the entryway roof. With a no. 6 flat, float Deep Periwinkle against the lower edge of the roof.

10 Load a no. 2 round with Snow (Titanium) White and paint a highlight along the edge of snow on the left-side eaves on the chapel and entryway. Load a no. 10 flat with Snow (Titanium) White and add some swooshes on the roof to create highlights and wavy snow.

11 With a no. 10 flat, float Mink Tan + Payne's Gray + Burnt Umber + water (3:1:1:6) on the back left edge and the far right edge of the entryway. Clean the brush and float Graphite along the chapel's left wall beneath the eaves.

Remove the masking film from the windows. Don't worry if you find that your cuts aren't as exact as the pattern. You can adjust any issues with the paint. Also, don't worry if some of your floated color gets on your snow, you can paint over it later.

12 Dampen the windows with plain water from the stained glass down. Stroke in some Primary Yellow with a no. 4 flat. Then from the bottom of the windows, stroke in a little bit of Snow (Titanium) White. While the paint is still wet, float Honey Brown across the tops with a no. 10 flat. Repeat this process for the round window on the front of the church.

13 For the stained glass, use a watery mix of the colors listed and a no. 1 round. The colors for the panes are Lavender, Festive Green, True Red and Sapphire.

14 With a pencil, very lightly draw in the window-panes. Use the no. 6/0 scroller to paint the trim around the panes. The trim on the front-facing window is Burnt Umber. The trim on the side windows is Bittersweet Chocolate. Use just the tip of the brush to create a very thin line. Add some snow to the windowsill with a little Soft Lilac on a no. 2 round. Paint the trim in the round window with Burnt Umber and paint Snow (Titanium) White on the sill.

15 Basecoat the door with Burnt Umber and a no. 6 flat. The paint will probably look streaky but that's

OK because in this case it will look more like wood. With a no. 1 round, stroke in shadow on the right side and the upper edge of the door with Bittersweet Chocolate. Make a faint line down the middle to simulate a crack. Basecoat the left side of the stairs with Graphite and a no. 4 flat. Use a no. 1 round to paint the right side of the stairs Graphite.

16 Paint the steps Snow (Titanium) White. Don't worry about covering up your stair lines. With a no. 6 flat float Soft Lilac against the right side of the steps. Use a no. 1 round and Graphite to apply a few horizontal lines along the stairs. The lines should not go all the way across the steps. Draw in the handrails with the soapstone pencil or chalk. Use a no. 6/0 scroller and Graphite to stroke in the banisters.

17

18

19

20

17 With the no. 6/0 scroller, add snow to the handrails with Snow (Titanium) White.

18 With a no. 6 flat, float some Deep Periwinkle on the bottom left side of the stairs.
Mix Black Green + Hauser Dark Green (1:1) and dab in the bush beside the stairway with a no. 2 round.

19 With a small, round scruffy brush, dab a mix of Deep Periwinkle + Soft Lilac (1:1) on the left side of

the bush. On the right side of the brush, dab on Soft Lilac. Add Snow (Titanium) White to the right side of the bush. You may want to add more Snow (Titanium) White after the first coat dries to brighten the snow.

20 With a no. 6 flat add a very watery wash of Primary Yellow onto the snow beneath the windows. Also dab this color onto the bush beneath the window. Add a touch of Primary Yellow to the underside of the eaves that are to the right of the round window.

Details

Deer

1 Paint the deer Honey Brown (two coats) with a no. 2 flat. Paint the rump Snow (Titanium) White.

2 Use Burnt Umber and a no. 3/0 round to add shading. To blend the shading, make a small brush mix of Burnt Umber + Honey Brown (1:1) and stroke this in between the two colors. This will merge the colors and give a smoother appearance. Notice the shading applied on the left ear before it is blended, and see how it has been blended on the right ear.

3 Mix Snow (Titanium) White + Honey Brown (3:1) and apply around the white rump to soften the line. Apply Snow (Titanium) White with a no. 3/0 round along the left side of the tail. Mix Honey Brown + Snow (Titanium) White (1:1) and stroke onto the back of the head, back and flank areas. Use a no. 3/0 round and blend into the Honey Brown base. Take care not to allow this highlight color and the Burnt Umber shading to touch.

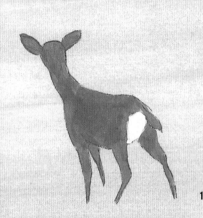
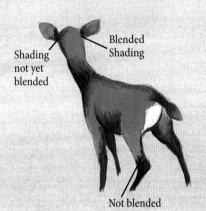
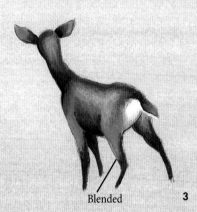

Shading not yet blended

Blended Shading

Not blended

Blended

1

2

3

Fence

1. Paint the fence posts Graphite with a no. 0 round. Highlight with strokes of Snow (Titanium) White and Graphite (2:1).

2. Use the no. 6/0 scroller and watery Burnt Sienna to paint the barbed wire. Curve the wire slightly to make it sag. Make the bottom wire in the center look buried in the snow by simply ending your stroke. Stroke in a tiny shadow in the snow where the wire goes into the snow. Use the tip of the no. 6/0 scroller to make tiny *X*s on the fence in Burnt Sienna.

Grass

Use the no. 6/0 scroller and watery Burnt Sienna to make blades of dead grass emerge from the snow. (See page 19 in the *Techniques* section for detailed instruction.)

Snow

Since you painted your canvas Snow (Titanium) White before beginning, the snow is already basecoated. Mix a watery blend of Snow (Titanium) White + Soft Lilac (2:1) for the shadows in the snow. Use a no. 10 flat and sweep this color across the snow where needed. Use blending gel if desired. Use a thicker mixture (less water) and a no. 1 round to paint the deer's tracks and shadow. Also use the thicker mix on the left side of the church where the snow would be shaded. Leave enough white area under the windows to streak in a little watery Primary Yellow for the glow from the windows.

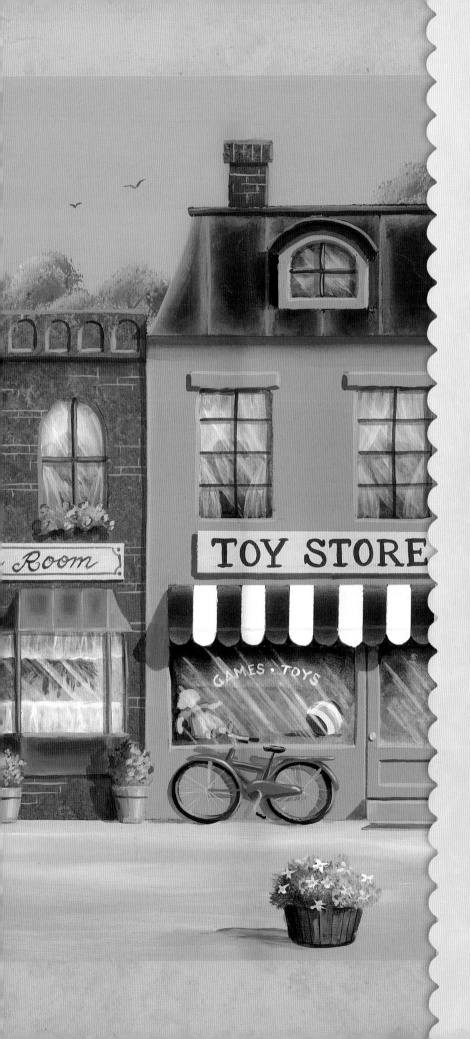

Summertime in the Village

Quaint storefronts are always a favorite of mine to paint, particularly because I can add so much detail. And I can include any kind of shop I want. Have fun when painting village scenes, and personalize them with your own store names!

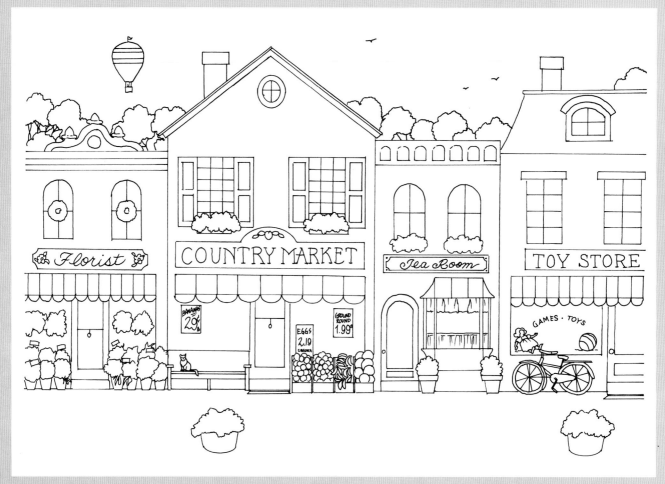

This pattern may be hand traced or photocopied for personal use only. Enlarge at 196% on a photocopier to bring it up to full size.

The buildings in *Summertime in the Village* are not stepped out as the other projects in the book are. The base, shade and highlight colors are named. All paints are DecoArt American Acrylics. Any techniques, such as the brick, clapboard siding, windows, trees and flowers, can be found fully explained in other projects in this book. Feel free to use your own colors or personalize the store names. Get creative and have fun with it!

Store signs and awnings are taped off for ease of painting. Use a no. 0 round for lettering. Signs in windows are white lettered with a no. 3/0 round. Paint reflection on windows after items behind glass are painted, such as the signs and toys. Use a circle template to make bicycle wheels round.

Sky and Trees
Paint the sky Baby Blue. Stipple the background foliage on with a scruffy brush and various shades of green (see page 17). Add distant birds with Raw Umber and a no. 3/0 round.

Sidewalk
Basecoat the sidewalk with Driftwood. Shade with Mississippi Mud and highlight with Bleached Sand.

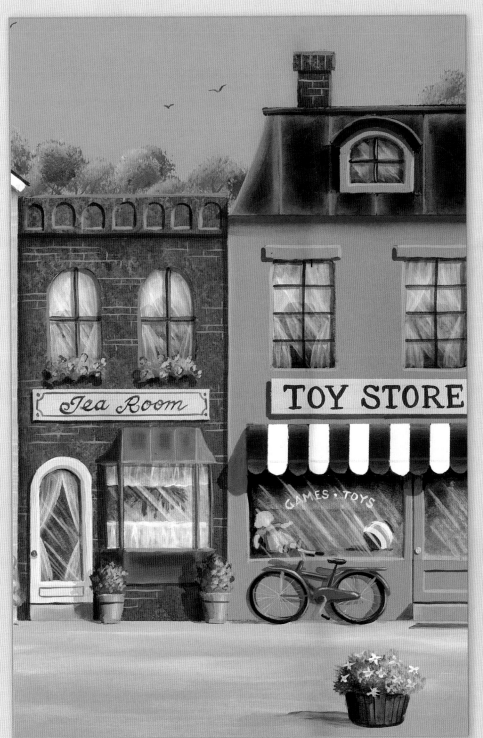

Toy Store

Base the building with Celery Green. Shade with Avocado and highlight with Celery Green + Snow (Titanium) White (1:1).

Paint the windows following the instructions in the *Country Farmhouse* painting (pages 20–29).

Basecoat the awning Evergreen and Light Buttermilk.

Paint the sign with Cool Neutral and Tomato Red.

The copper roof is painted with Burnt Umber and Green Mist. Follow the instructions for the copper roof in the *English Tudor* painting (pages 56–67).

Paint the bicycle with Sapphire, Ebony (Lamp) Black and Snow (Titanium) White.

Paint the chimney following the instructions on page 100.

Tea Room

Follow the painting brick instruction on page 34 to paint the building. Shade with Heritage Brick and highlight with Heritage Brick + Snow (Titanium) White (1:1).

Paint the roof of the bay window following the copper roof instructions in the *English Tudor* painting (pages 56–67).

The sign and door are painted with French Vanilla and trimmed with Blue Haze.

Country Market

The clapboard siding on the Country Market is painted using the same techniques found in the *Little Cape Cod* painting (pages 68–77). Basecoat the building with Cool Neutral. Shade with Mississippi Mud and highlight with Light Buttermilk.

The shutters are Napa Red shaded with Antique Maroon. Add Snow (Titanium) White to Napa Red to create the highlight color edges.

Paint the awning Napa Red and Light Buttermilk.

The fruits are painted with Pumpkin, Tomato Red, Primary Yellow and Light Avocado. Highlight with Snow (Titanium) White.

Paint the flower boxes following the instructions in the *Italianate Cottage* painting (pages 30–43).

Florist

Basecoat the building with French Vanilla. Shade with Camel and highlight with Light Buttermilk.

Paint the awning with Heritage Brick and Light Buttermilk.

The sign is Snow (Titanium) White, Evergreen and Boysenberry Pink.

The flowers are painted with Pumpkin, Tomato Red, Boysenberry Pink, Primary Yellow, Snow (Titanium) White and Lavender.

Flower Barrels

Basecoat the flower barrels with Burnt Umber. Shade with Ebony (Lamp) Black and highlight with Burnt Umber + Snow (Titanium) White (2:1).

Stipple the foliage in the barrel following the instructions on page 17. Create white blooms with Snow (Titanium) White and a no. 3/0 round. Dab in Marigold centers.

Hot Air Balloon

Basecoat the balloon with Snow (Titanium) White, Tomato Red and Marigold. Shade with Grey Sky, Napa Red and Pumpkin. Highlight the red areas with Tomato Red + Snow (Titanium) White (1:1) and the yellow areas with Marigold + Snow (Titanium) White (1:1).

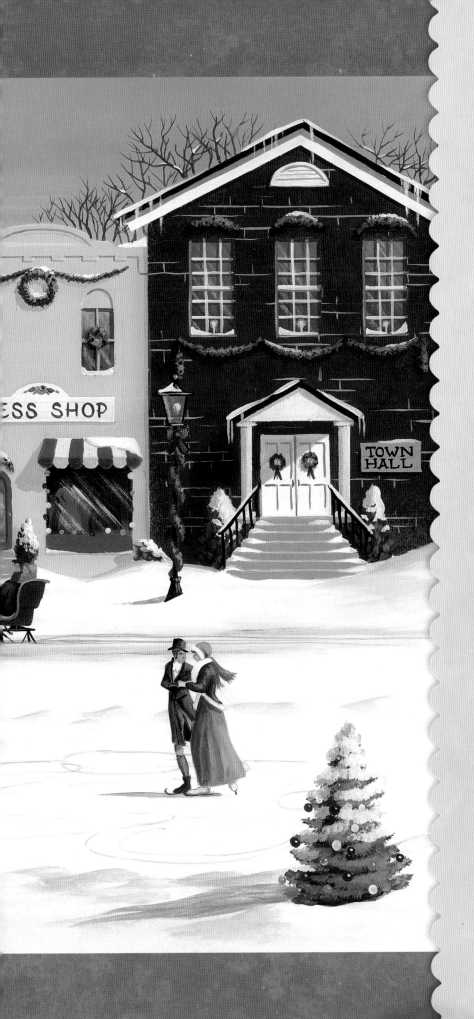

Village Christmas

Christmas scenes

are always fun to paint, and I love to create villages such as this with lots of holiday touches. Like the *Summertime in the Village* project, there is room for you to personalize this painting with your own store names. Here's an idea: Once you complete your Village Christmas, share it with everyone by either scanning it or taking a photograph; print them out and make your own special Christmas cards!

This pattern may be hand traced or photocopied for personal use only. Enlarge first at 200% on a photocopier and then enlarge this photocopy at 108% to bring it up to full size.

The buildings in *Village Christmas* are not stepped out as the other projects in the book are. The base, shade and highlight colors are named. All paints are DecoArt Americana Acrylics. Any techniques, such as painting brick, windows, floating, snow, etc. can be found fully explained in other projects in this book. Feel free to use your own colors or add your own details. Have fun and make it your own!

Lettering on signs is done with a no. 3/0 round.

Shortcut
Basecoat your entire canvas or paper with Cool White before transferring the pattern.

Sky and Trees
Paint the sky Baby Blue, adding Snow (Titanium) White as you reach the horizon.

For the distant trees, create a watery mix of Graphite and Avocado (1:2) and add a touch of Snow (Titanium) White to make a gray-green. Then stipple (pounce) this color on with a scruffy brush.

Snow
Basecoat the snow with Cool White. See the *Chapel in Winter* painting (pages 102–113) for instruction on shading the snow. Highlight with Snow (Titanium) White.

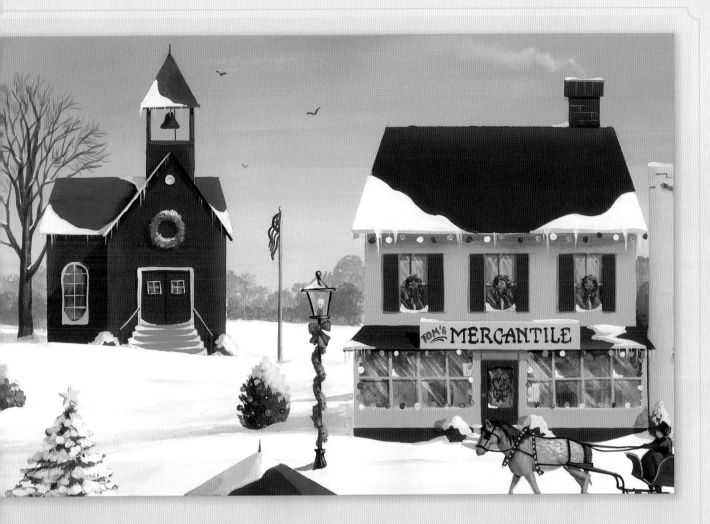

School

Basecoat the school with Tomato Red. Shade with Napa Red and highlight with Cadmium Red. Paint the roof Graphite and shade with Ebony (Lamp) Black. The steps are Slate Grey.

The window is Payne's Grey trimmed with Snow (Titanium) White.

Flag

Paint the flagpole with Slate Grey highlighted with Snow (Titanium) White and Slate Grey (1:1) on the right. Paint the flag with a no. 0 round using Snow (Titanium) White to undercoat. When dry, paint the field Payne's Grey, and the stripes True Red. Use the point of a straight pin to add a semicircle of stars in Snow (Titanium) White.

Tom's Mercantile

Basecoat the building with Camel. Shade with Honey Brown and highlight with Camel + Snow (Titanium) White (1:1).

Paint the roof Dark Chocolate and highlight with Milk Chocolate.

The door and shutters are Heritage Brick. The sign is Antique White, True Red and Ebony (Lamp) Black.

Paint the windows following the instructions in the *Country Farmhouse* painting (pages 20–29), but substitute Tomato Red and Camel for the Avocado in those instructions.

The Christmas lights are created with the dip dots technique (page 13) undercoated first with Snow (Titanium) White. When the white paint is dry, use bright colors on top (still using the dip dot method) and put a speck of Snow (Titanium) White on each ball with a toothpick. Colors used here are Festive Green, Yellow Light, Calypso Blue, True Red and Vivid Violet. Tinsel on the tree is applied with the no. 6/0 scroller and a mix of Camel, Yellow Light and Snow (Titanium) White (1:1:1).

Lampposts

Paint the lampposts Ebony (Lamp) Black with a no. 0 round and highlight with Slate Grey. Make the highlight brighter on top of the first highlight with a touch of Snow (Titanium) White. Paint the light bulb Snow (Titanium) White. When dry, make a very watery, transparent mix of Snow (Titanium) White and paint the glass. Add snow with Snow (Titanium) White and a no. 0 round. Add the garland following the direction on page 125.

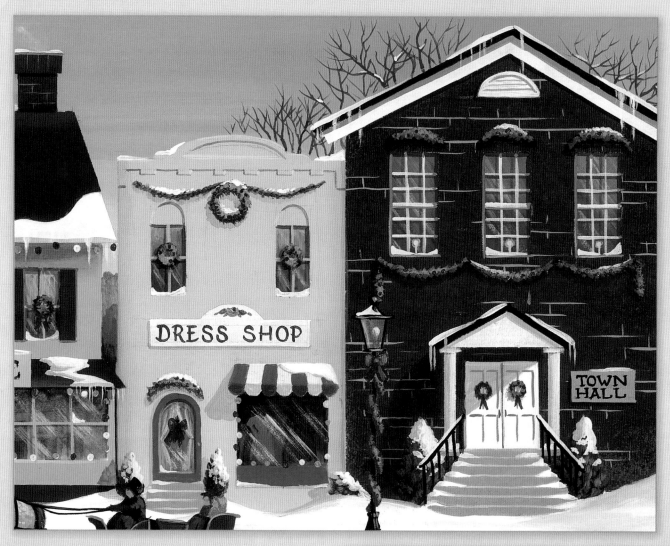

Dress Shop

Basecoat the building with Soft Sage. Shade with Celery Green and highlight with Soft Sage + Snow (Titanium) White (1:1).

Paint the door and window trim with Avocado shaded with Evergreen. The windows are Payne's Grey.

Paint the awning with Avocado and Antique White.

The sign is Soft Sage + Snow (Titanium) White (1:1) and True Red.

Paint the steps with Driftwood.

Town Hall

Follow the brick painting instructions on page 34 to paint the building. Shade with Antique Maroon and highlight with Heritage Brick + Snow (Titanium) White (1:1).

The trim is Snow (Titanium) White, Driftwood and Ebony (Lamp) Black. Shade the white part of the trim with Slate Grey.

Horse

Basecoat the horse with Slate Grey. Shade the body with Graphite and highlight it with Snow (Titanium) White. Its tail and mane are Ebony (Lamp) Black highlighted with Graphite. The harness is Ebony (Lamp) Black, Napa Red and Camel.

Sleigh

Basecoat the sleigh with True Red. Shade with Napa Red. The runners are Ebony (Lamp) Black highlighted with Slate Grey.

Gazebo

Basecoat the gazebo with Snow (Titanium) White. Shade with Grey Sky.

Paint the roof Dark Chocolate. Shade with Milk Chocolate and highlight with Burnt Umber.

Skaters

The male skater's coat and hat are Payne's Grey highlighted with Payne's Grey + Snow (Titanium) White (1:1). His trousers and socks are Milk Chocolate shaded with Dark Chocolate and highlighted with Milk Chocolate + Snow (Titanium) White (1:1).

The female skater's hat, scarf and skirt are Light Avocado. Shade with Avocado and highlight with Celery Green. Her coat is True Red. Shade with Napa Red and highlight with True Red + Snow (Titanium) White (2:1).

Details

Paint the Christmas trees and shrubs with Evergreen. Shade them with Black Green and highlight with Light Avocado.

Use a no. 3/0 round to lay Snow (Titanium) White onto all ledges, tree branches, windowsills and wreaths and anything that would collect snow. Refer to page 107 for instruction on painting snow on trees. Icicles are painted with Snow White and a no. 1 round. Paint the icicles off the eaves and over-

hangs using a short, tapered stroke, making sure to keep them straight and vertical.

Wreaths and garland: Stipple (pounce) Evergreen with a very small scruffy, then highlight with Light Avocado + Snow (Titanium) White (1:1). Use a toothpick to undercoat the berries first with Snow (Titanium) White, then dab on True Red. Bows are undercoated first with Snow (Titanium) White and a no. 3/0 round, then painted True Red. Remember that undercoating with white always makes a color stand out when it's against a dark background.

Snowman

To make the snowman stand out in the snow, first make sure there is a wash of snow shadow behind him (see pages 102-113 for instructions on shading snow). Paint the snowman Snow (Titanium) White, and float snow shadow on the left side of his body using a no. 8 flat. Use a no. 0 round to dab on some shadow at his waist. Paint his hat Slate Grey and shade with Graphite. Paint his arms, face, buttons and scarf with a no. 0 round, using Graphite for the arms, eyes and buttons; Cadmium Orange for his nose; True Red and Festive Green for his striped scarf. Make sure you include tiny shadows (use snow shadow) cast by the eyes, nose, buttons, left arm and scarf. Use a no. 2 round to lay some heavy (darker) snow shadow behind the snowman.

Resources

U.S. Retailers

Liquid Shadow©
www.kerrytrout.net

The Artist's Club
13118 N.E. 4th St.
Vancouver, WA 98684
Tel: (800) 845-6507
www.artistclub.com

Americana Acrylic Paints
DecoArt
P.O. Box 386
Stanford, KY 40484
Tel: (800) 367-3047
www.decoart.com

Scharff Brushes, Inc.
P.O. Box 746
Fayetteville, GA 30214
Tel: (888) 724-2733
Fax: (770) 461-2472
www.artbrush.com

Canadian Retailers

Crafts Canada
120 North Archibald St.
Thunder Bay, ON P7C 3X8
Tel: (888) 482-5978
www.craftscanada.ca

Folk Art Enterprises
P.O. Box 1088
Ridgetown, ON N0P 2C0
Tel: (800) 265-9434

MacPherson Arts & Crafts
91 Queen St. E. P.O. Box 1810
St. Mary's ON N4X 1C2
Tel: (800) 238-6663
www.macphersoncrafts.com

Index

The best in art instruction is from North Light Books!

Landscapes In Bloom

Let your paintbrush and imagination take you on a stroll through lovely landscapes. Ten complete step-by-step acrylic projects show you how to paint idyllic scenes brimming with blooming flowers. Full-color photos, detailed instructions, traceable patterns, color swatches and detailed materials lists make these projects easy for painters of any skill level.

ISBN-13: 978-1-60061-101-8, ISBN-10: 1-60061-101-X, paperback, 128 pages, #Z2037

Paint Charming Seaside Scenes

Capture the charming moods of seascapes in colorful and inviting acrylic paintings. Fifteen projects guide you through the painting process step by step. You'll also find instructions on painting lighthouses, rocks, dunes, fishing shacks and sunsets.

ISBN-13: 978-1-60061-059-2, ISBN-10: 1-60061-059-5, paperback, 128 pages, #Z1751

Painter's Quick Reference: Birds & Butterflies

Turn here for tons of instruction and inspiration when you're looking to paint beautiful birds and butterflies! Many of today's most popular artists have come together to bring you a garden full of winged beauties. With more than 40 projects in a variety of mediums, including acrylics and oils, you're sure to find the perfect painting subject.

ISBN-13: 978-1-60061-031-8, ISBN-10: 1-60061-031-5, paperback, 128 pages, #Z1357

Brilliant Color

Discover the freedom of "pushing the envelope" when choosing colors for your landscape paintings. Ten step-by-step demonstrations and dozens of colorful mini-demonstrations show you how to break the bonds of the traditional "color rules." Easy-to-understand diagrams and color swatches teach you basic color principles without bogging you down with difficult color theories.

ISBN-13: 978-1-60061-058-5, ISBN-10: 1-60061-058-7, paperback, 144 pages, #Z1677

These books and other fine North Light books are available at your local arts and crafts retailer, bookstore or online supplier or visit our web site at www.mycraftivity.com.